Mushroom Magick

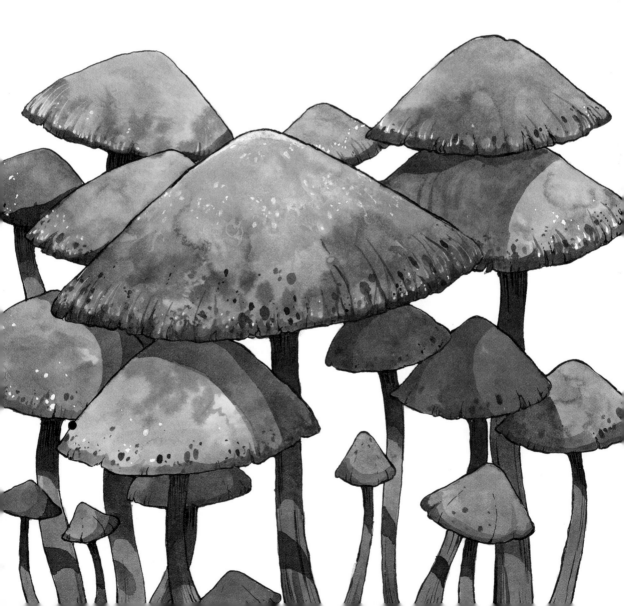

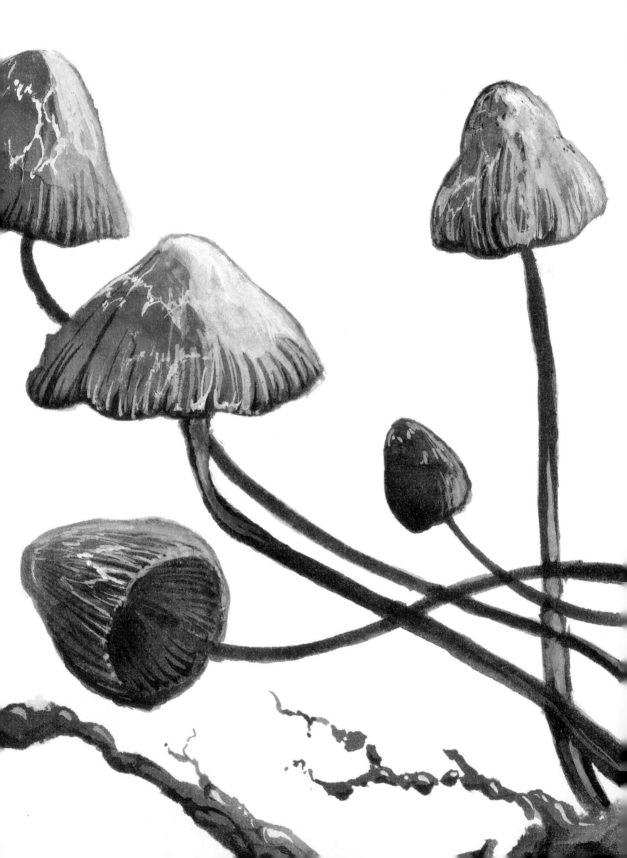

A Visionary Field Guide

Mushroom Magick

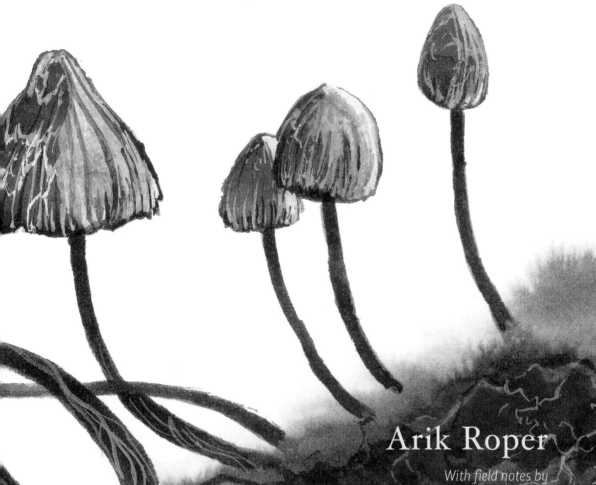

Arik Roper

*With field notes by
Erik Davis, Daniel Pinchbeck, and Gary Lincoff*

ABRAMS, NEW YORK

Contents

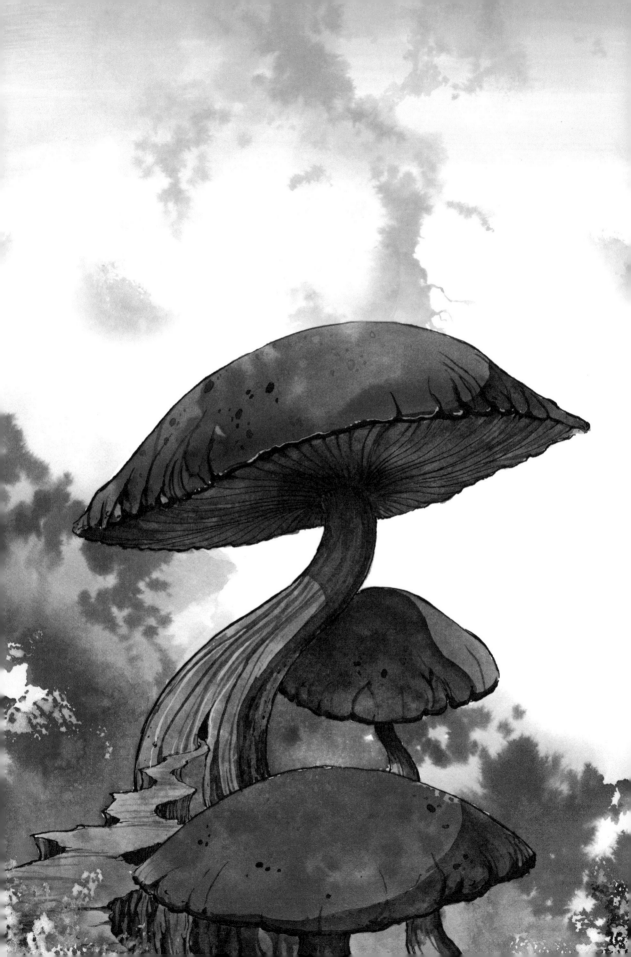

Foreword

by Daniel Pinchbeck

In Arik Roper's extraordinary paintings, he imparts a cheerful, luminous personality to the "magic mushrooms" known to shamanic cultures around the world, from reindeer-herding Siberian nomads to tribal people in South America. It has been only a half-century since the modern West rediscovered the visionary powers of psilocybin. Although officially interdicted, psychedelic mushrooms continue to inspire artistic visions and musical beats, while inciting creative breakthroughs in other fields, such as communications technologies and animation software. By showing the mushrooms in all of their multihued and eldritch glory, Roper's portfolio celebrates the influence of these fungal sacraments, which have spread their inspiration, spore-like, across our modern world.

While nodding to the history of psychedelic art from the sixties and beyond, from Fillmore concert posters to album cover illustrations, Roper's work turns the mushrooms themselves into the rock stars, shifting the focus of our cultural imagination from the human to the nonhuman world that surrounds us. This, in itself, is an alteration of consciousness. Our postmodern world is currently reappraising the psychedelic experience that was rejected and repressed after the sixties. Numerous studies now underway, given government approval, are exploring the use of these long-forbidden visionary catalysts as tools of psychotherapy and healing. A recent research project at Johns Hopkins University, for example, gave psilocybin to a group of people who had never taken a psychedelic before. The study found that most of the subjects described long-term positive changes in their worldview as a result of the experience. This study

confirmed the results of similar research from the sixties, and was given favorable coverage by the mainstream media.

At the same time, we continue to learn more about mushrooms in general, which turn out to be, genetically, closer cousins to humans than to plants. The brilliant mycologist Paul Stamets has studied the vast "mycelial mats," which can grow to thousands of acres underground and live for thousands of years, and considers them to be a biological "internet" or neural network, constantly adapting and interacting with the environment. He theorizes that these vast life forms are conscious and intelligent, functioning like vast exteriorized brains: "I say they are sentient, because they produce pharmacological compounds—which can activate receptor sites in our neurons—and also serotonin-like compounds, including psilocybin, the hallucinogen found in some mushrooms." Stamets believes "there is an evolutionary common denominator" between fungi and us: "We evolved from fungi. We took an over-ground route. The fungi took the route of producing these underground networks that are highly resilient and extremely adaptive: if you disturb a mycelial network, it just re-grows. It might even benefit from the disturbance." Stamets has discovered species of mushrooms with extraordinary properties for "bioremediating" landscapes that have been polluted by modern industry, as well as other species that offer extraordinary health benefits. Mushrooms are not just our cousins, but also our friends.

The history of modern use of the magic mushrooms began with the investment banker R. Gordon Wasson and his wife, Valentina, who visited Mazatec shamans in the mountains of Oaxaca, and published an extraordinary account of their discoveries in *Life* magazine in 1957. Wasson later regretted this deeply. The *Life* magazine article brought the sacred mushrooms to the attention of "hippies and trippers," including rock stars and their hangers-on, who descended on the little mountain town of Huautla de Jimenez, in search of fungal gnosis, over the next decades.

I often ponder on the Wassons' quest, through remote Mexican mountains and obscure etymologies, to discover the lost secrets of *teonanacatl*, the "wondrous mushroom" of Mesoamerica. The story is a Nabokovian fable, complete with its requisite supporting cast of aged indigenous wisdom-keepers, CIA spooks seeking new tools for mind control, and a Greek chorus of gray-bearded ethnobotanists. archaeologists, and poets. What began as a cookbook-writing project—a

hobby for a successful investment banker and his wife—turned into an epic pursuit of revelation and gnosis, transforming their lives, and, eventually, the lives of many others, as well.

Nabokov was, of course, a Russian expatriate, as was Valentina Wasson. While the Wassons pursued truffles, Nabokov was a passionate collector of butterflies, and he employed those delicate, rainbow-hued creatures throughout his fiction as his favorite symbol for the liberating flights of the human imagination. In the Wassons' real-life fable, the fluttering butterfly is replaced by the purplish caps, the "fruiting bodies" that the indigenous shamans revered and fed to their foreign guests in nighttime ceremonies called *veladas*. Where the butterflies offered a literary metaphor, the mushrooms acted as direct catalysts for the visionary impulse, unleashing floods of supersensible perception.

The Wassons discovered their vocation accidentally, when Wasson was repulsed by his wife's enthusiasm for a group of edible toadstools she picked in the woods outside their home in the Catskill Mountains of New York. She insisted on eating the fungi; he thought she was going to expire on the spot. "Like all good Anglo-Saxons," Wasson wrote, "I knew nothing about the fungal world and felt that the less I knew about those putrid, treacherous excrescences the better." For his wife, on the other hand, "they were things of grace, infinitely inviting to the perceptive mind."

The Wassons' innocent desire to fathom the difference between mycophilic cultures and mycophobic cultures led them, inexorably, from removed scholarly curiosity to direct shamanic ecstasy. One can only imagine their surprise at this turn of events. As they followed the clues, they were pulled deeper into the labyrinth of the past, toward the hermetic mysteries of Mesoamerican traditions—and, perhaps, the preliterate origins of religion around the world.

Researching linguistic clues and folklore, the Wassons found an "aura of the supernatural in which all the fungi seem to be bathed." They began to discern traces of a lost mushroom cult, and ventured a startling hypothesis: "was it not possible that, long ago, before the beginnings of written history, our ancestors had worshipped a divine mushroom?" And if it was possible, could such a religion still survive, in some obscure corner of the Earth? But why would anyone deify a mushroom? Seeking the answer to this riddle led them to the Mazatec Indians in the remote mountains of Oaxaca, Mexico, following faint rumors of an extant

mushroom cult. In the summer of 1955, their quest led them to the Mazatec shamaness Maria Sabina, who would play the role of Virgil in their saga, guiding them on Dantesque surveys of the far antipodes of the psyche. Wasson admired her greatly, calling her "a woman of rare moral and spiritual power, dedicated in her vocation, an artist in her mastery of the techniques of her office." At Sabina's home, they ate the mushrooms in total darkness, with the shamaness and her daughter chanting and singing beside them.

Initial reports of new discoveries often have a crystalline precision that is lacking from the tales of those who make the same experiment later. It is as if some primordial quality of revealing is only available to those who take the first step through the looking glass, and uncover some new dimension of human knowledge. Wasson's beautifully written accounts of his mushroom veladas convey that impression. He describes a profusion of psychedelic bounty flowing from the astral world—a true psychedelic baptism. In his first sessions, Wasson perceived geometrical forms, mythological divinities, magical processions, and archaic landscapes. He witnessed patterns that "grew into architectural structures, with colonnades and architraves, patios of regal splendor, the stone-work all in brilliant colors, gold and onyx and ebony, all most harmoniously and ingeniously contrived, in richest magnificence extending beyond the reach of sight." These hallucinatory constructs seemed to belong "to the imaginary architecture described by the visionaries of the Bible."

The chants and cries and percussive sounds made by Sabina and her daughter carried him into realms of turbulent vision, beyond his control. "For the first time that word 'ecstasy' took on subjective meaning for me," he recalled in his book, *The Wondrous Mushroom.* "'Ecstasy' was not someone else's state of mind. It was no longer a trite superlative cheapened by overuse and abuse. It signified something different and superior in kind, which I could now testify as a competent witness." The be-mushroomed state was nothing like intoxication in the ordinary sense of the term. Despite the sensory overload, Wasson was not narcotized or intoxicated in any normal sense. He found that his rational intellect remained intact throughout his journey: "The mind is attached as by an elastic cord to the vagrant senses."

Brought to mainstream attention by Wasson's work, the mushrooms took their place in the psychedelic carnival of the 1960s, and were quickly outlawed, labeled "Schedule One" substances of abuse, with no medicinal value, along with

other visionary compounds considered sacred by indigenous people around the world, such as mescaline, iboga, and DMT. Although they grow naturally and wildly across much of the Earth, eating the mushrooms in order to trip is still forbidden today. Having decried their trivialization by the 1960s counterculture, Wasson would not venture an opinion on the eventual fate of the entheogens in our desacralized modern world: "Whether chemists and therapists will find some lasting use for the extraordinary substances that we have discovered in these strange plants, I will not predict," he writes. "The awe and reverence that these plants once evoked seem to me gone for good. Their utilization for 'recreation' is, certainly, a passing fad."

When Timothy Leary visited Wasson in the early 1960s, he was baffled by Wasson's negative attitude about contemporary uses of the mushroom: "Although these fungi had produced all of the great philosophic visions of antiquity, he proclaimed they had no relevance to the modern world," Leary recalled. Appalled by the modern misuse of Sabina's "little children"—her term for the playful mushroom spirits—Wasson retracted into the mode of the scholar and mandarin. It was left to boisterous advocates such as Leary to promote psychedelia to the masses.

Wasson defined a number of crucial characteristics of the shamanic traditions of the Mazatecs. One of the most interesting is that the mushrooms are believed to "speak" through the medium of the shaman. Years later, Maria Sabina described how the mushroom trance came over her: "I see the Word fall, come down from above, as though they were little luminous objects falling from heaven. The Word falls on the Holy Table, on my body: with my hand I catch them, Word by Word." The Mazatec shaman speaks the words dictated by the mushroom, channeling them in rhythmic incantations.

In his essay "The Mushrooms of Language," Henry Munn, a friend of Wasson's who lived among the Mazatecs, described the linguistic inspiration that is a profound aspect of the mushroom trance: "Those who eat them are men of language, illuminated with the spirit, who call themselves the ones who speak, those who say." The shaman's ability to heal is inseparable from this inspired speech imparted by the mushrooms. Munn writes, "The Indian shamans are not contemplative; they are workers who actively express themselves by speaking, creators engaged in an ontological, existential disclosure." The indigenous shamans are enunciators, vessels through whom the sentient and wise mushroom expresses itself.

It has been fifty years since the extraordinary work of Gordon and Valentina Wasson introduced the "wondrous mushroom" to the modern Western psyche. It may be the case that the deeper meaning of this encounter is still revealing itself—that the official demonizing and countercultural abuse of "shrooms" is only a chapter in a much longer and more interesting story, one that we are still far from fully grasping. Following in the footsteps of Wasson and Leary as psychedelic scholar and philosopher, the late Terence McKenna wrote and spoke about his transformative encounter with mycelial intelligence while in the Colombian Amazon, in the early 1970s. During a week of intensive exploration, McKenna was told by the voice of the mushroom that it was an ancient star-faring species interested in making a productive symbiosis with humanity. As McKenna related, the fungal consciousness explained that it distributed itself through the galaxy as spores, traveling on meteorites, awaiting contact with the nervous system of a higher animal capable of conscious evolution. "The mushroom which you see is the part of my body given to sex thrills and sun bathing," the fungus informed him. "My true body is a fine network of fibers growing through the soil." These mycelial networks "may cover acres and have far more connections than the number in a human brain." Psilocybin and psilocyn were compounds produced to open the psycho-physical gateway to a galactic community of mind.

McKenna was given a message to share with the human tribe: "You as an individual and humanity as a species are on the brink of a formation of a symbiotic relationship with my genetic material that will eventually carry humanity and earth into the galactic mainstream of the higher civilizations." Such a prospect still seems outlandish to many. But as McKenna notes, it is only our prejudices that make us think an alien intelligence would use the kind of technologies we create, like rockets and ray guns, rather than expressing itself via the invisible, perfected technology of nature. It is, in any event, intriguing that the mushroom would reveal itself to nontechnological tribal peoples as a form of divine revelation, and introduce itself to the post-modern mind through a discourse that incorporates space travel and genetics.

My personal hypothesis is that the recovery of the relationship between the human mind and the visionary intelligence accessed through entheogenic plants has great significance for the future of humanity. When I look at my own life, I find that psychedelics such as mushrooms, iboga, and ayahuasca have been

crucial in my development, acting as teachers and therapists. They have also functioned as philosophical tools, introducing me to different concepts of time and multidimensional arrays of possibility and perhaps-ness. While I have no desire to worship the mushroom, I feel tremendous gratitude for the wisdom it has imparted to me, and the mysteries it has revealed.

The psychedelic art and awareness of the 1960s may represent a first stage in a mass cultural voyage of shamanic initiation—and it is possible that the second stage of this archetypal journey is just getting underway. Wasson lamented the "brutal, bulldozer-like" impact of the modern world on indigenous traditions. He noted that the shaman "bears in his person the charisma of a village mediator with the spirits of the invisible world. How extraordinary that in this nuclear age so ancient a form of religious expression still survives, for a few more years, in the remote regions of the world!" He did not foresee the possibility that the archaic, shamanic modes of perception and action might eventually influence and even reshape the dominant modern culture, turning it away from its rigid rationality and bringing back intuitive modes of thought and perception. For McKenna, this was the prospect suggested by an "archaic revival" of the shamanic consciousness in our time: "The Logos can be unleashed, and the voice that spoke to Plato and Parmenides and Heraclitus can speak again in the minds of modern people. When it does, the alienation will be ended because we will have become the alien."

As we race toward an increasingly uncertain future, facing ecological meltdown and economic collapse, we may want to learn to consider the perspective of those nonhuman others who inhabit this earth with us, and seem eager to share their wisdom. Developing cross-species relations requires a kind of diplomacy. By giving us such a stunning visual portrayal of psychoactive mushrooms as presences— simultaneously factual and folkloric, literal and legendary—Roper's artwork helps to build a bridge between the realm of sentient mycelia and our all-too-human form of awareness. The seemingly humble fungus—able to live on excrement, breakdown toxic materials, and impart insights both humorous and profound—could become a culture hero and poster child for a new planetary culture. By humanizing and personifying our elder cousins in the community of life, Roper's work can help us make an evolutionary shift in perspective.

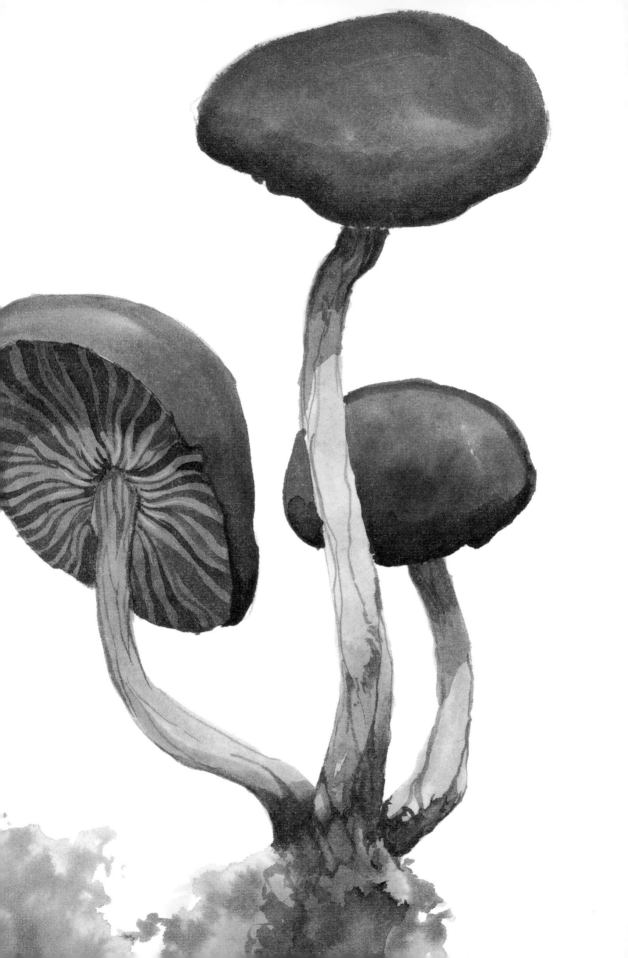

INTRODUCTION

Shroom with a View

by Erik Davis

Mushrooms are all about appearances. They emerge in the dark of night or the blink of an eye, and sometimes disappear just as quickly. Now you see them, now you don't. No wonder the ancients thought they were germinated by thunderbolts: they don't seem to grow out of the soil so much as to pop out of thin air. And now we know that the mushrooms that do show up on the surface of things are themselves just transient representatives of a more lasting organism: the branching tangle of multi-cellular fungal threads that lie hidden beneath the soil. Under certain conditions of temperature and moisture, this internet of mycelium—sometimes vast, and sometimes ancient—sends up fruiting bodies like periscopes in order to distribute reproductive spores. The mushroom, then, is already an icon of itself, appearing in our visible world of fields and forests like an avatar of some deeper, subtler spirit.

The appearance of the mushroom bodies themselves resemble nothing else on Earth, even though these shapes so often remind us of other things: hats and

goblins, umbrellas and cocks, or furniture for toads. Goofy and exotic, elfin and obscene, mushrooms are caricatures of themselves. Their colors are often vivid and strange as well: blue-blacks and purples and rusty sunset blazes that seem more like the work of *fin-de-siècle* bohemian artists than the cheery sign painters who give birds and flowers their bright and happy hues. Some mushrooms even glow in the dark.

Growing out of rot or turd, in damp caves or along dead tree stumps, mushrooms appear in worlds that lie between life and death, animal and plant. Is it any wonder that our ancestors, making their way through the enchanted landscapes of life before science, associated mushrooms with the uncanny, with mischief and sorcery, with spirit transport and immortality? This occult legacy is still inscribed in the common names of so many species: Magecap, Witches Hat, Destroying Angel, Devil's Urn, Jack-O-Lantern. Or consider the dozens of mushroom species whose fruiting bodies form rings or arcs on meadows and the forest floor. Can you fault the old ones for calling these designs "fairy rings"—*ronds de sorciers* in French, *hexenringe* in German—or for claiming that they mark the circle dances of pixies or hags? Even the Japanese call their fly agarics *tengutake*—goblin mushroom.

Mushrooms are all about appearances, and appearances deceive. Even as the ancient Taoist sages wandered through their misty pine mountains hunting for the Marvelous Fungus that grants eternal life, many other mushrooms can—and do— kill. In English we find a traditional linguistic divide between *mushrooms* (edible) and *toadstools* (deadly), but the distinction, like most black-and-white moral schemes, does not hold. The mushroom is fundamentally undecidable. Experts still confuse tasty and poisonous specimens, while the classification of mushroom species itself remains a notoriously hairy and fractious scientific problem. "The more you know them, the less sure you feel about identifying them," said the composer John Cage, an ardent mycophile. "It's useless to pretend to know mushrooms. They escape your erudition." Embodying both elixir and toxin, healing and bane, the mushroom may be biology's purest example of what Plato called a *Pharmakon*—a term, or a drug, that can mean and be both poison and medicine.

Somewhere between immortality and death, poison and medicine, lies the realm of visions. Given the mushroom kingdom's enchanted profile in folklore, is it any wonder that within its alkaloid pharmacy there exists a handful of molecules that shift and magnify the human mind? Over 180 species of mushroom contain psilocybin and/or its near relative psilocin, the main psychoactive ingredients in the

"magic mushrooms" or simply "shrooms" that are now found and gobbled across the planet. A smaller set of Amanitas—the most famous being the red-coated, pearl-spotted fly agaric, the most caricatured of all mushrooms—contain muscimol and ibotenic acid, which are also powerful if not more tricky hallucinogens. Other, weirder species lurk in the wings, half-grokked blends of toxin and drug.

Mushrooms are all about appearances, and the visions that come with a few dried grams of shrooms are nothing if not a stream of appearances. At low doses, the visible world of rocks and clouds takes on a mirthful incandescence that blooms, on the inner screen of the eyelids, into mosaic patterns, self-ingesting mandalas, and other abstract convolutions. At higher doses the mushroom seems to act like a portal into other dimensions. As waves of powerful emotions—awe, bliss, terror, hilarity—bathe the mammal body, the be-mushroomed person becomes what the psychedelic mycologist Gordon Wasson, echoing Emerson, famously called a "disembodied eye." Cyclopean palaces and blinking UFOs may rise out of lost junglescapes, while insect lords and almond-eyed goddesses play hide and seek behind shimmering veils of alien hieroglyphs. It can seem as if one's mind has become the stage for an apocalyptic mystery play whose final, flirting curtain promises a revelation of such cosmic import that it threatens to unravel the very texture of time and self.

Given such jaw-dropping phantasmagoria, it is understandable that some students of the mushroom believe that in the fungus they have stumbled across the hidden origins of human religion. Perhaps the most celebrated of these students was Wasson himself, a Wall Street banker who, in a 1957 edition of *Life* magazine, revealed the existence of a "magic mushroom" cult of peasant healers in the remote mountains of Oaxaca. Given the great deal of evidence we have for pre-Columbian use of Psilocybe mushrooms in Mesoamerica, Wasson reasonably believed that he had discovered the smoldering embers of an ancient tradition. Wasson also went on to argue that psychedelic fungi contributed the secret sauce for *soma*, the mystical brew lovingly described in the Vedas of India, as well as for the *kykeon* guzzled during the ancient mystery rites of Eleusis.

Wasson was hardly alone. In 1970, John Allegro published *The Sacred Mushroom and the Cross*, which argued that the origins of Christianity were fungal as well, a secret encoded in the Eucharist. Druids and Vikings were also believed by some to be magic-mushroom eaters, an argument that went down well in a counterculture

striving to ground its own hallucinogenic explorations in deep history. In the early 1990s, the scintillating psychedelic bard Terence McKenna picked up the thread and wove an even larger tale. As the rave scene was sparking a new wave of mushroom gobbling around the globe, McKenna argued that the mushroom's semiotic rocket-ride kick-started language itself, and that human consciousness can be traced to the first ancestor who decided to munch some of the cow-pie companions that popped up on the Serengeti plains. In other words, mankind *is* mushroomkind.

But appearances can deceive. Despite the fact that the spores of Psilocybe mushrooms carpet-bombed wide swaths of our planet millennia ago, there is little hard evidence for psychedelic mushroom use in traditional societies—even among groups that consumed other mind-expanding plants and brews. Along with Mesoamerica, where royal weddings were capped with mushroom-fueled dance parties, the only other bulls-eye is Siberia, where shamans (and ordinary folks) consumed *Amanita muscaria*, the non-Psilocybe-containing fungus whose psychoactive alkaloids were also passed around through the quaffing of urine. In Europe, there is scant suggestion of mushroom use, despite the ubiquity of Liberty Caps and other species. Solidly documented cases of probable Psilocybe intoxication begin in the eighteenth century, and they suggest that these accidental shroomers discovered nothing partly cosmic or worthwhile in their trips—although some did get the giggles.

Nonetheless, a number of authors insist that a hidden mushroom cult of fungal gnosis, rooted in Neolithic shamanism, has been passed down secretly. Given our theme here, what's most interesting about the evidence they marshal is how much of it depends on *the appearance of mushroom-like images*. As far as the Neolithic past goes, McKenna was particularly fond of a rock-art image from Tassili, Algeria, which depicts a wizardly character with a horned, bee-shaped head and a body covered with some very suggestive protuberances. Looking toward the Middle Ages and the Renaissance, Clark Heinrich and James Arthur point to mushroom-shaped anomalies drawn from alchemical texts, illuminated manuscripts, and bronze panels from medieval cathedrals. Even the modern commercial images of Santa Claus—a magical figure in red and white clothes who flies through the air and lives in the frozen north—has been interpreted as residue of Siberia's Amanita shamanism.

As James Arthur writes in his pro-conspiracy *Mushrooms and Mankind*, "It seems when you start to look, there is mushroom imagery everywhere." But mushrooms are all about appearances—even if you catch them out of the corner

of your eye, it's hard to know what they mean. The shapes on the Tassili figure may be fattened arrowheads, or the sort of abstract designs that permeate rock art around the world. Medieval iconologists identify the spindly mushroom tree on the oft-mentioned bronze panel from Hildesheim as a stylized *ficus*. For true believers, the fragmentary nature of this evidence simply confirms the sneakiness of the cult. On the other hand, there is a great irony in taking mushroom shapes found in art *literally*, as unambiguous evidence for the existence of psychedelic magical-religious rituals along the lines of the ones Wasson found in Oaxaca. For the message that the mushroom delivers to the eye of the beholder seems to suggest another story: that appearances themselves are a trickster, glamour, and a phantasm. Now you see it, now you don't.

There is another way to capture the ambiguous appearance of the mushroom, and that is simply to illustrate them as accurately as possible. This is the tradition of natural science, and as far as mushrooms are concerned it goes back at least to a Renaissance botanist named Clusius, who illustrated and described a number of Hungarian mushroom groups in his 1601 monograph *Fungorum in Pannoniis Observatorum Brevis Historia*. Images as well as words were always key in these texts, and the crude wood-block engravings in Clusius's book were based on gorgeous watercolors by an unknown hand. Over a century later, Pier Antonio Micheli published his exhaustive *Nova Plantarum Genera*; seventy-three plates accompanied the book, in which Micheli described the mushroom's spore-happy reproductive cycle for the first time. In English, James Sowerby published four volumes of his *Coloured Figures of English Fungi* around the turn of the eighteenth century, while the Frenchman Émile Boudier weighed in a hundred years later with the lithographs for his massive *Icones Mycologicae*. In all these botanical studies, science is intertwined with art, and therefore with imagination, since even the most exacting quest for visual accuracy is compelled by the nature of the mushroom to delineate the weird and wonderful.

Psychedelic species regularly pop up in these collections, especially the colorful fly agaric, while Sowerby became the first to warn about the intoxicating properties of *Psilocybe semilanceata*, also known today as Liberty Caps. But proper psychedelic field guides did not begin to appear until the early 1970s, when intrepid North American mushroom geeks started turning the expanded-

consciousness crowd on to the fact that cousins of Mexico's legendary magic mushrooms grew on home turf. The images and information that accompanied these early guides was often inaccurate, and as the field guides improved, they tended to back up their data with photographic literalism rather than artistic illustration. While Wasson's *Life* article was accompanied by Roger Heim's glowing watercolors of various Psilocybe species, and charming drawings packed Richard Schultes's highly illustrated 1976 *A Golden Guide to Hallucinogenic Plants*, the era of scientific mushroom art was beginning to wane. When Paul Stamets published his definitive *Psilocybe Mushrooms & Their Allies* in 1978, full-color photographs accompanied it.

The seventies were also the decade that the mushroom became established as a central visual icon of the counterculture. Rock art posters by Rick Griffin and Stanley Mouse included the little critters, as did underground comics by Vaughn Bodé and flyers for venues (like San Fernando Valley's Magic Mushroom Club). One notably delightful fungal fantasy appeared inside of the Allman Brother's 1972 double album *Eat a Peach*. Pathetically small in the CD reissues and nonexistent on iTunes, the image unfurls as an enchanted but down-home landscape of humanoids happily sharing their space with dozens of bejeweled mushrooms in various shapes and sizes—a giddy comic-book otherworld that simultaneously references Hieronymus Bosch, Mexican mural art, and the album covers of Mati Klarwein, not to mention the millions of stoned pen-and-ink doodles that were being cranked out in homerooms across the land. Twenty years later, when rave music resurrected a psychedelic culture of trance dance and inner-eyelid imagery, mushroom iconography exploded once again, becoming an underground logo of otherworldly consciousness that popped up on party fliers, CD covers, and T-shirts.

On the one hand, these countercultural images are simply the latest iteration of the mushroom's perennial association with mystery and enchantment. This is the same visual tradition that placed Lewis Carroll's smoking caterpillar on a mushroom, that packed toadstools into Victorian fairy paintings, and that drove the dancing Amanitas in Disney's *Fantasia*. But countercultural shroom images are more than storybook icons—they also symbolize the biological host, the actual organic vehicle of the very same visual consciousness that gives so many of these images their wobbly, organic edge. Form becomes content becomes form. Just look at the beautiful line drawings that the ethnobotanist Kat Harrison created to accompany

Psilocybin: Magic Mushroom Grower's Guide, the path-breaking 1976 underground handbook of mushroom cultivation written pseudonymously by Terence McKenna and his brother Dennis. Harrison's images are charming and impish, but they are also sensitive and accurate—a naturalist's response to the seemingly supernatural gifts of mushroom consciousness, a mind state where science and imagination became allies united on the plane of appearances.

Arik Moonhawk Roper's *Mushroom Magick* is another manifestation of that alliance. On the one hand, the book you hold resembles a typical botanical guide. All the species named and pictured are the real deal, and they are all packed to the gills with some manner of psychoactive alkaloids. At the same time, Roper has allowed the spirit of the mushroom to alter and enhance his illustrations of their bodies. Colors are intensified into hallucinations, while various lines and shapes—the brims of the caps, the flare of the stems—have been exaggerated. Roper's aim is not to turn mushrooms into caricatures, but to reveal their character, to blend the inner and outer worlds, and so to reveal the mushroom as much for what it does as for what it is. So don't attempt to use *Mushroom Magick* as a traditional field guide—unless the field you are exploring is the field of perception, of mind, of spirit.

Roper is the ideal supernaturalist for the task (Moonhawk is his real middle name, by the way, a gift of his artist parents). A native New Yorker, born in 1973, Roper trained at the School of Visual Arts before going freelance as an illustrator and graphic designer. He established his name creating strange and evocative LP and CD covers for bands like Sleep and High on Fire, who are known for dark and gnarly witchery that, like Roper's visions, pull you in and under. Roper has worked with poster design, animation, and a T-shirt or two, but his work remains devoted to a singular vision of meaty psychedelic otherworlds and their spectral inhabitants. As with *Mushroom Magick*, Roper pushes the conventions of fantasy illustration toward an extreme of organic and demonic pop. One senses the influence of early-seventies fantasy, poster, and comic-book illustration—of Vaughn Bodé, Ralph Bakshi's *Wizards*, Richard Corbin, Roger Dean, and *Heavy Metal* magazine. But this ambiance is only a gateway into deeper and older currents of the imagination, as if the nimbus of nostalgia that hovers around his work is really a longing for the enchanted world of nature itself—the ancient faeryscape whose invisible spores lie everywhere, ready to germinate, to reappear.

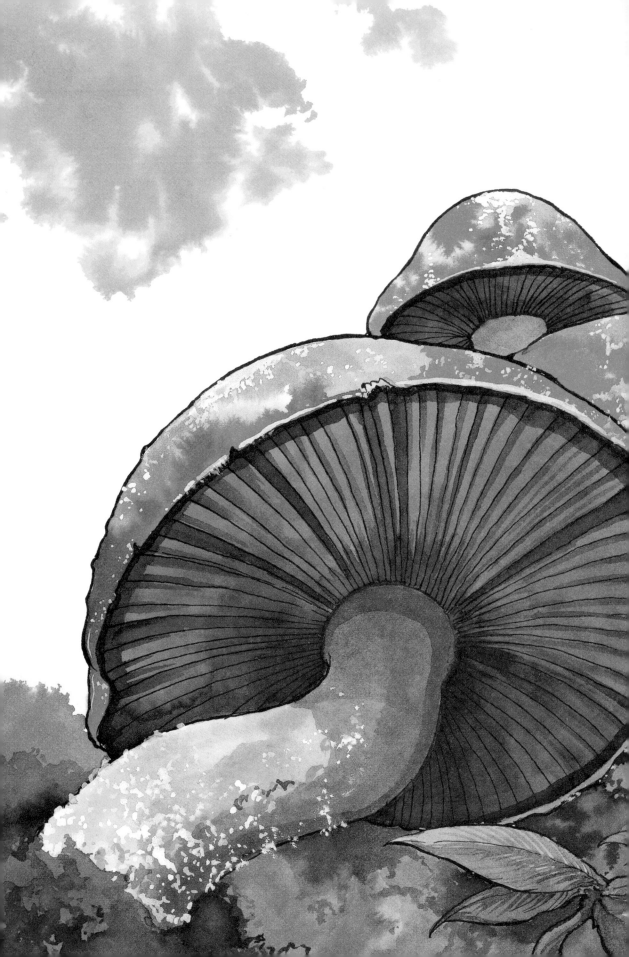

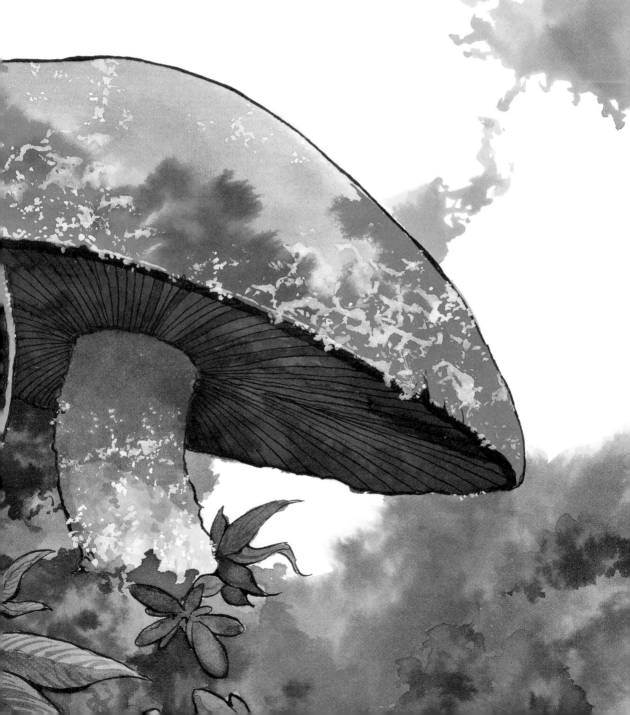

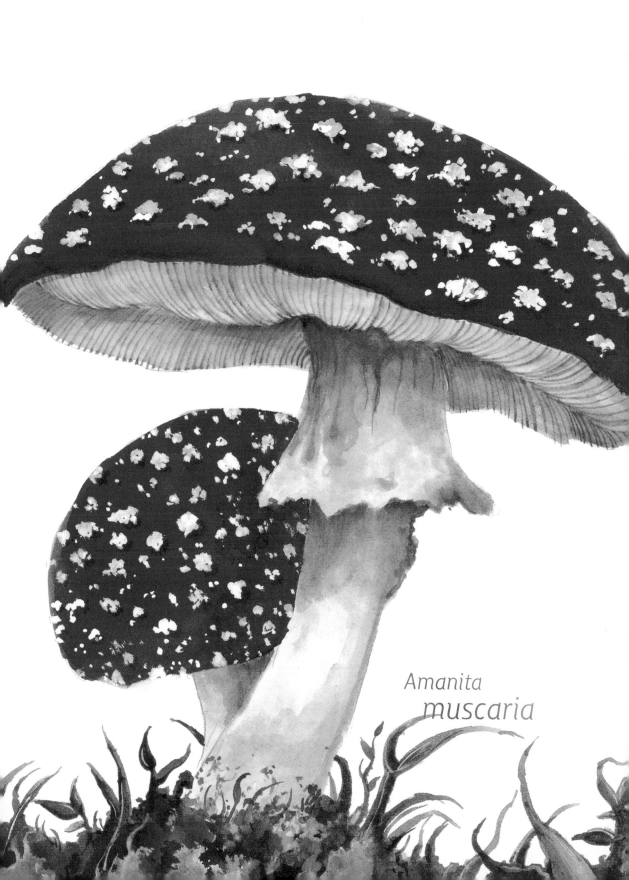

Amanita
muscaria

Amanita is a genus of very conspicuous,

often colorful, gilled mushrooms that occur worldwide, wherever there are conifer forests or hardwoods that include oak, beech, or birch. All species of Amanita begin life inside an egg-like membrane, rising up out of it as they grow. The remnants of the "egg" adhere as patches, often in circular patterns, on the mushroom cap. What is left can be found about the base of the stem. Sometimes there is a large sac-like cup about the stem base, or the "egg" remains are just patches or rows of scale-like remnants. In most species there is also a membrane covering the underside of the cap of the emerging mushroom. This breaks when the cap expands and leaves an annulus, or ring of tissue, about the upper stem. The gills of an Amanita—the thin radial plates under the cap—are white, and this is where the spores are formed and dispersed. A spore print can be obtained by placing a cap gill side down on a note card and leaving it for a couple of hours. The resulting print will be white.

There are hundreds of different kinds of Amanita. A few are popular edibles, others are somewhat poisonous, and two kinds are the most deadly of all mushrooms in the world. The all-white Destroying Angel (*Amanita virosa*, sometimes referred to by other scientific names) and the somewhat greenish-capped Death Cap (*Amanita phalloides*) are so toxic that a single mushroom can be a deadly dose. The most beautiful mushroom in the genus is called the Fly-Agaric (*Amanita muscaria*). It is the white-spotted, red-capped mushroom that adorns many children's books. Although it is listed as poisonous in many field guides, it can be eaten by those who know how to prepare it, and it is used as an inebriant in shamanic rituals among ethnic minorities in the Russian Far East.

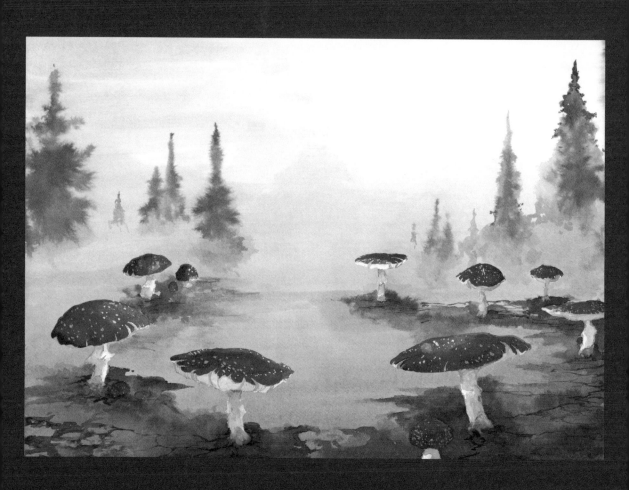

Amanita muscaria

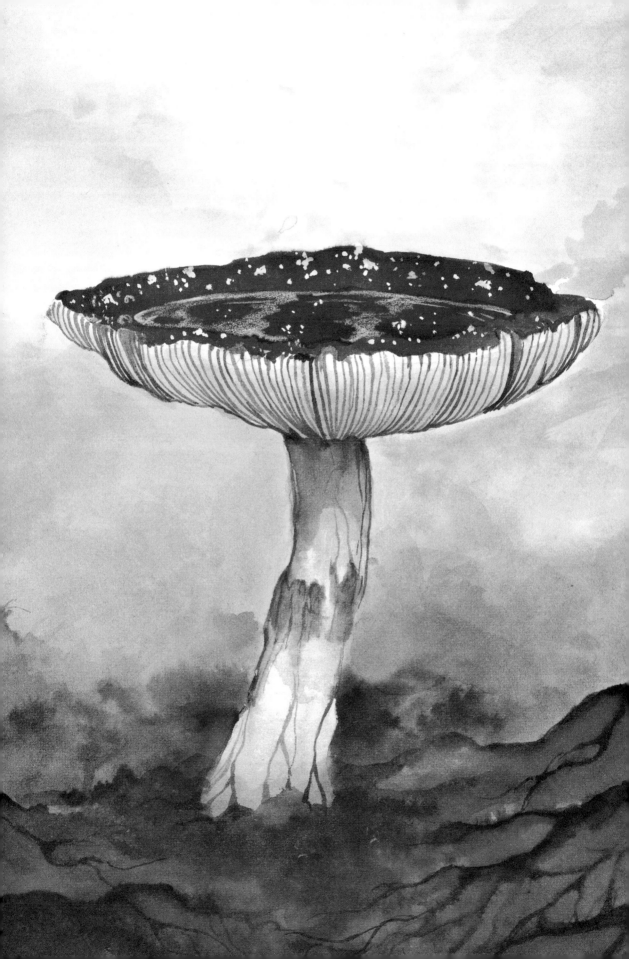

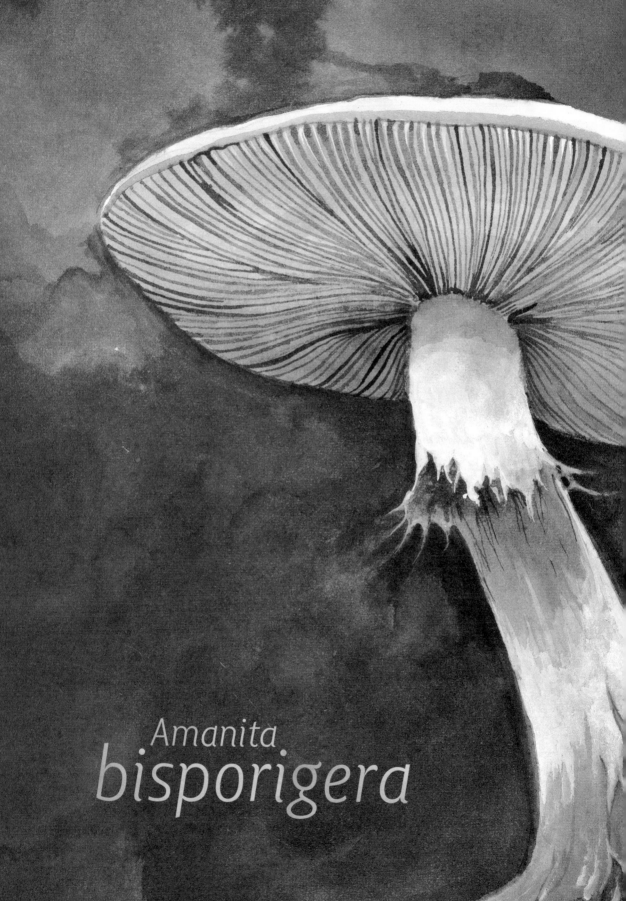

Amanita
bisporigera

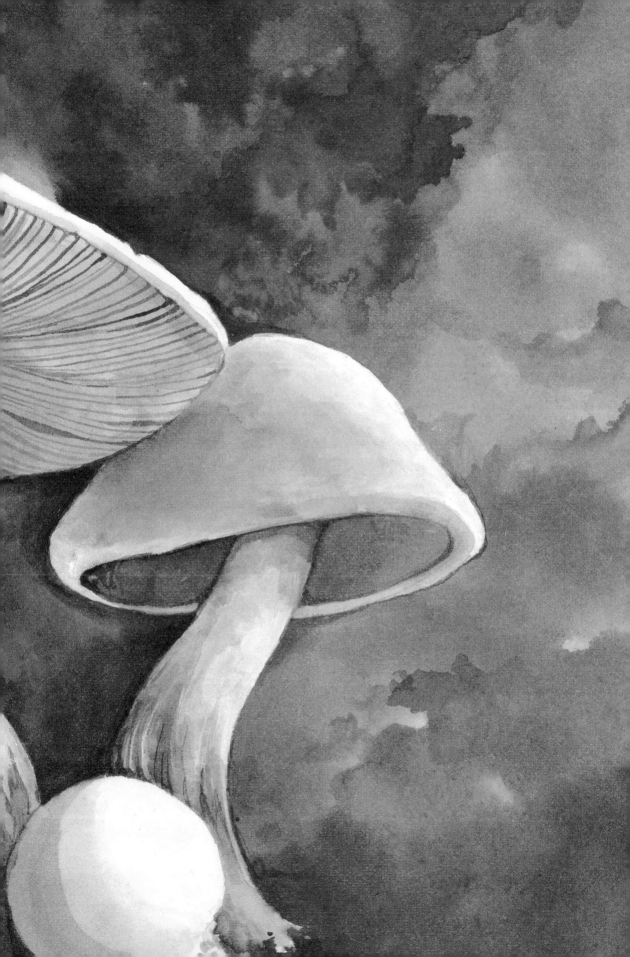

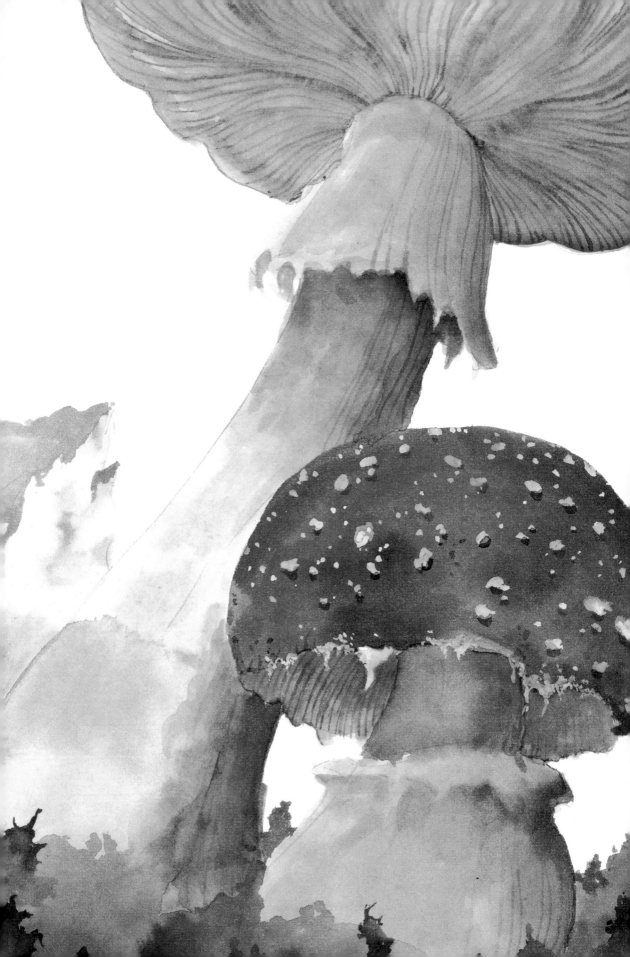

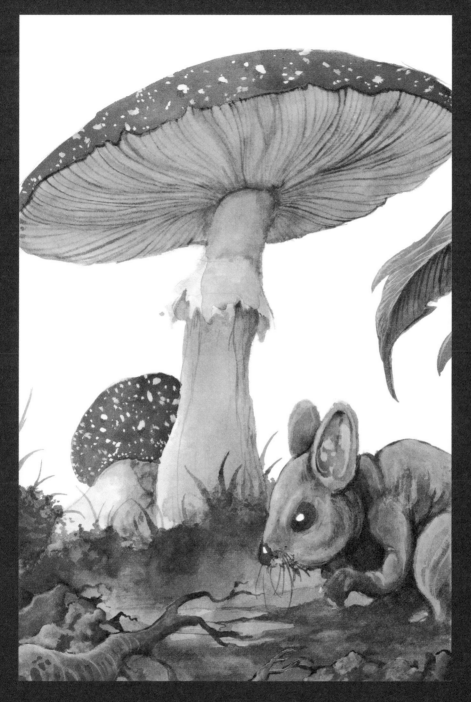

Amanita pantherina

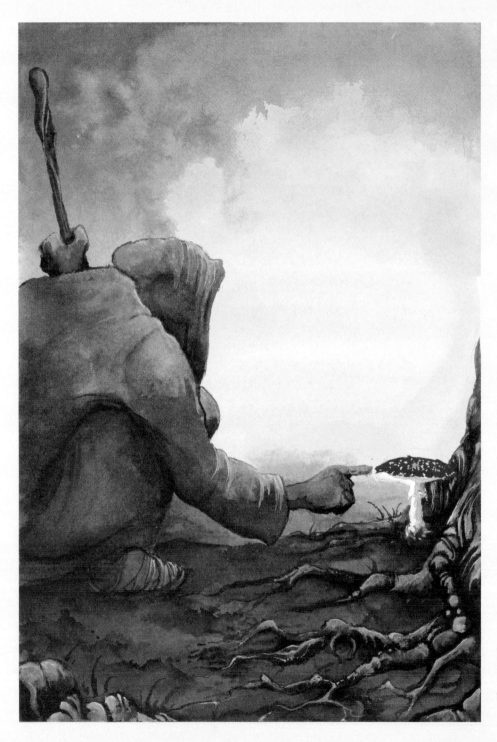

Amanita muscaria

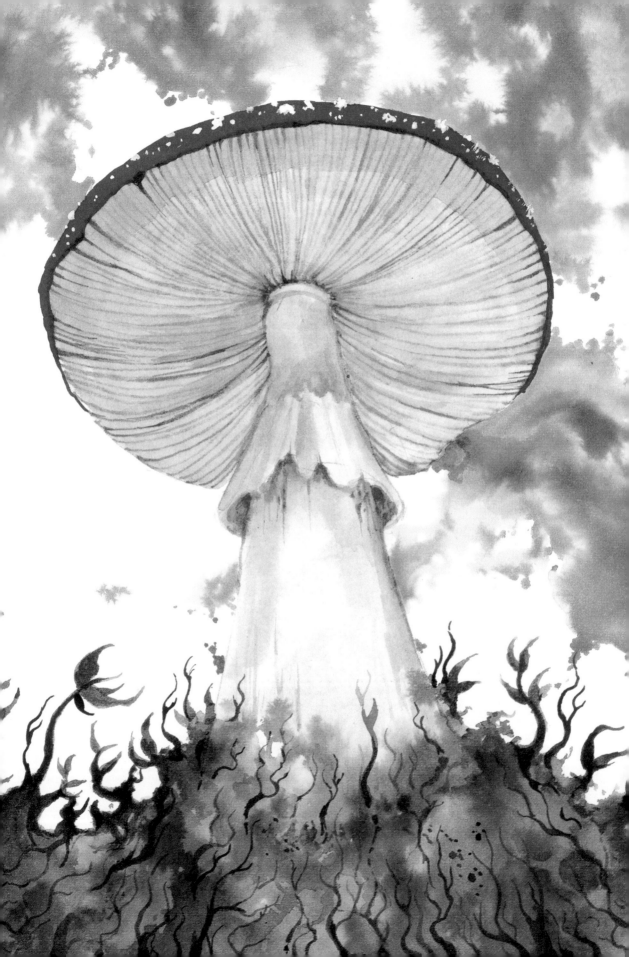

Boletus
manicus nonda

The boletes are a large group of

primarily forest mushrooms that grow on the ground. They have caps with a spongy under-surface and stalks. Although some boletes stain a blue or greenish color on bruising, this does not indicate the bolete is psychoactive (unlike the case with gilled mushrooms). All boletes grow associated with trees like conifers and a variety of broad-leaved trees like oaks, beech, birch, and poplars. The cepe or porcini or steinpilz (*Boletus edulis*) is world famous as a choice culinary mushroom, but several others are equally good. A few boletes are known to cause gastric upsets—some more so than others—and some are just too bitter to eat. But none is known to be dangerously poisonous, making the boletes the safest group of wild mushrooms for beginners to pick.

One bolete in Papua New Guinea (*Boletus manicus*) has the reputation of being psychoactive. It has been reported that local people have become crazed under the influence of this mushroom, but this might have more to do with a ritualized cultural response than any purported psychoactive compound in its tissues; the mushroom could be toxic. It is similar in appearance to the poisonous Satan's Bolete (*Boletus satanus*), a white-capped mushroom with a red spongy under-surface that stains blue on bruising.

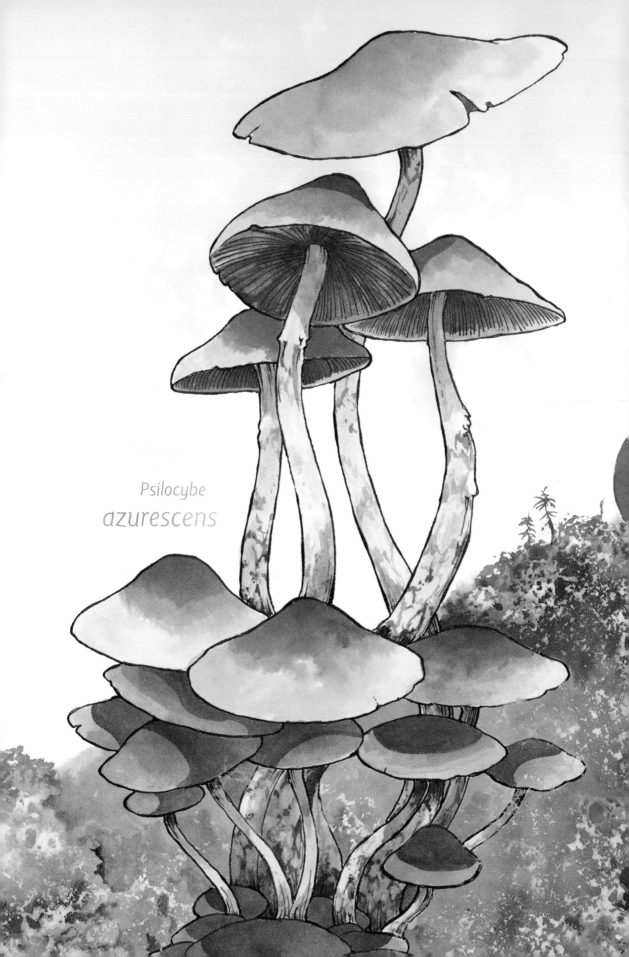

Psilocybe
azurescens

Psilocybe

Psilocybes are what people mean

when they say "magic mushrooms." And the species of Psilocybe that are magic

mushrooms are those that stain blue on bruising. There are many species of

Psilocybe that do not stain blue and these contain no psychedelic compounds,

but all the mushrooms that do stain blue contain the compounds psilocybin

or psilocin or both. All Psilocybes are small mushrooms with mostly thin stems

that grow on wood, in wood-chip mulch, or fruit out of manure. They are classic

decomposers. They typically have a brownish, somewhat slippery cap, and gills

that are also a brownish color. A spore print made from placing the mushroom

cap gill side down on a note card and left alone for a few hours will reveal a

purplish-brown print.

While a great many of the psychoactive species of Psilocybe occur in

Mexico, where they are still used in shamanic healing ceremonies, there are

different species of psychoactive Psilocybes along the Gulf Coast and up the

west coast of North America, from San Francisco to Vancouver, British Columbia.

Other kinds occur in Europe, Morocco, South Africa, India, east and southeast

Asia, Australia, and New Zealand. While the intensity of the experience may vary

depending on the mushroom used and the dose, the duration is the same for

all—about three to four hours.

Care must be taken not to mistake these Psilocybes with the deadly

species of Galerina, little brown mushrooms that grow on wood or in grass and

have a ring on their stem. Deadly Galerinas contain the same lethal toxins as the

Destroying Angel Amanitas!

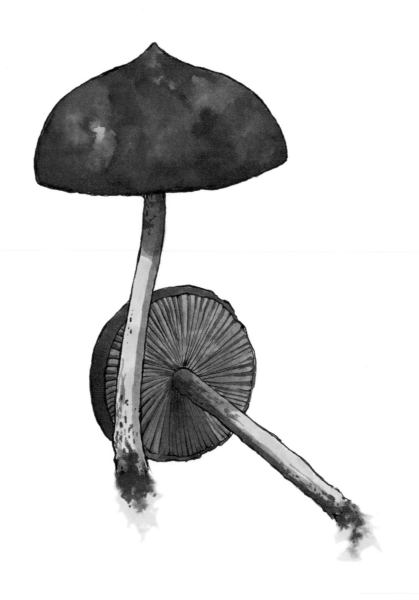

Psilocybe
atrobrunnea

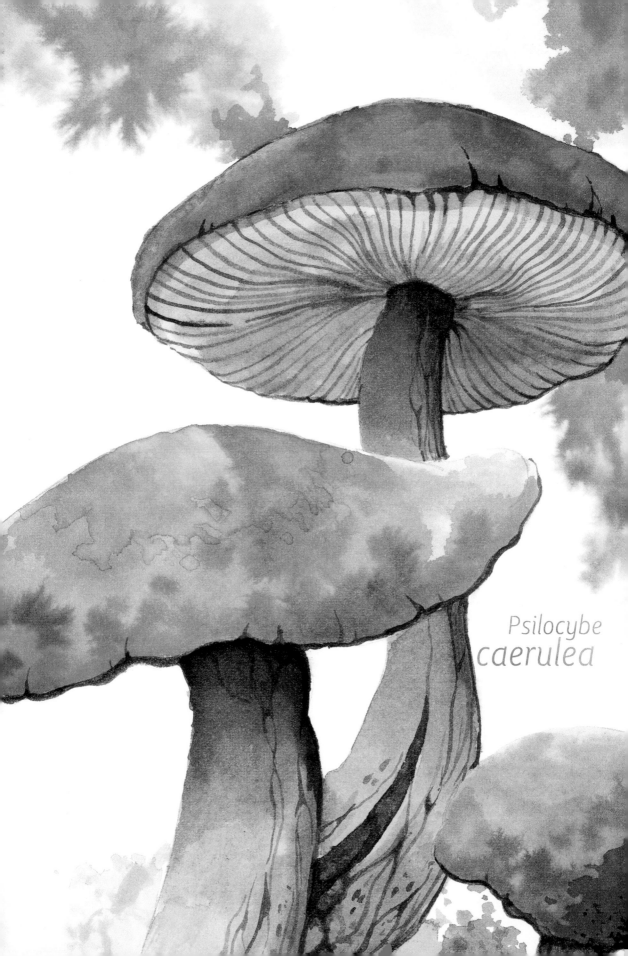

Psilocybe
caerulea

Psilocybe
aucklandii

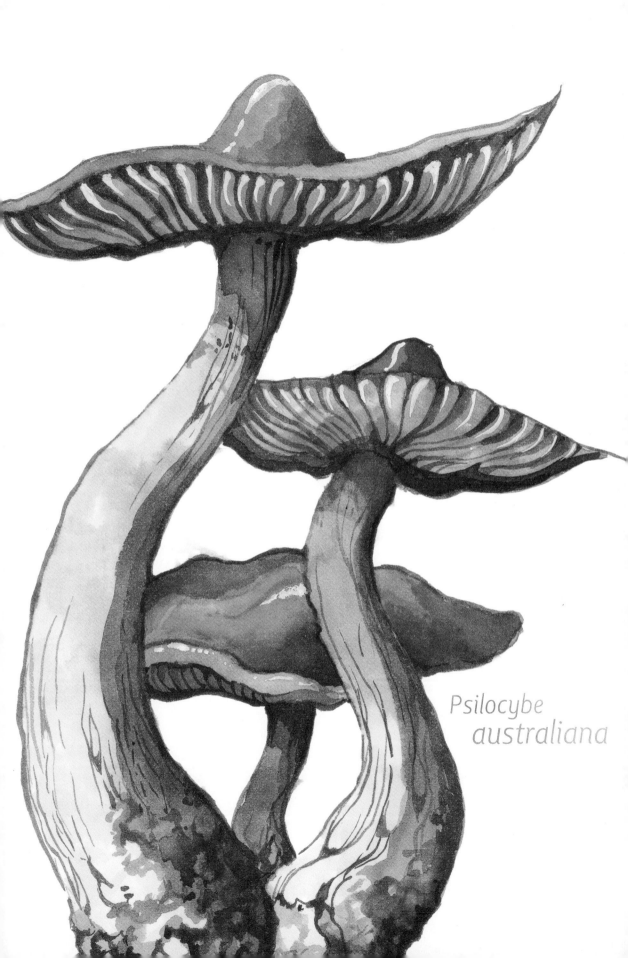

Psilocybe
australiana

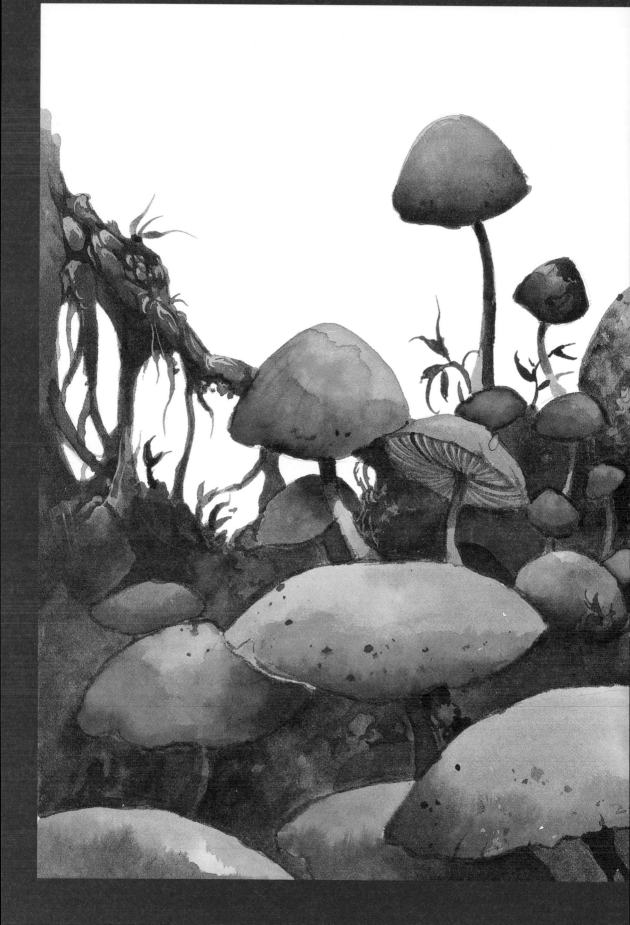

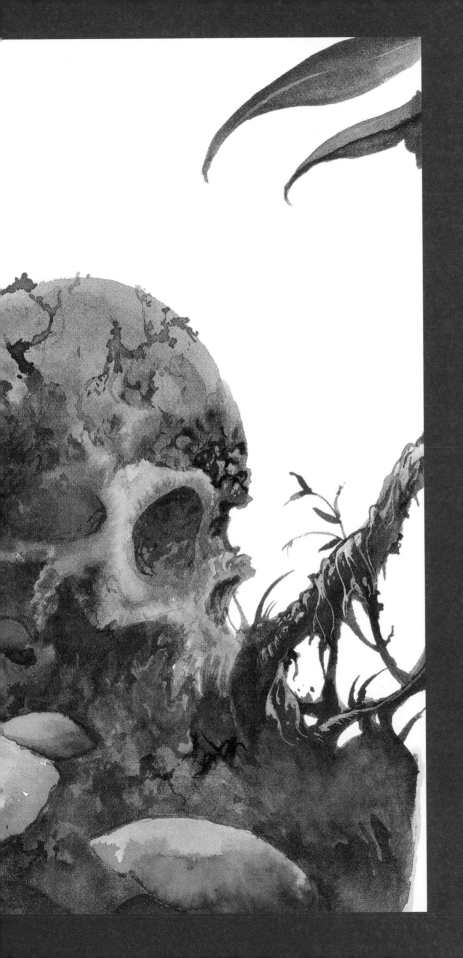

Psilocybe
aztecorum

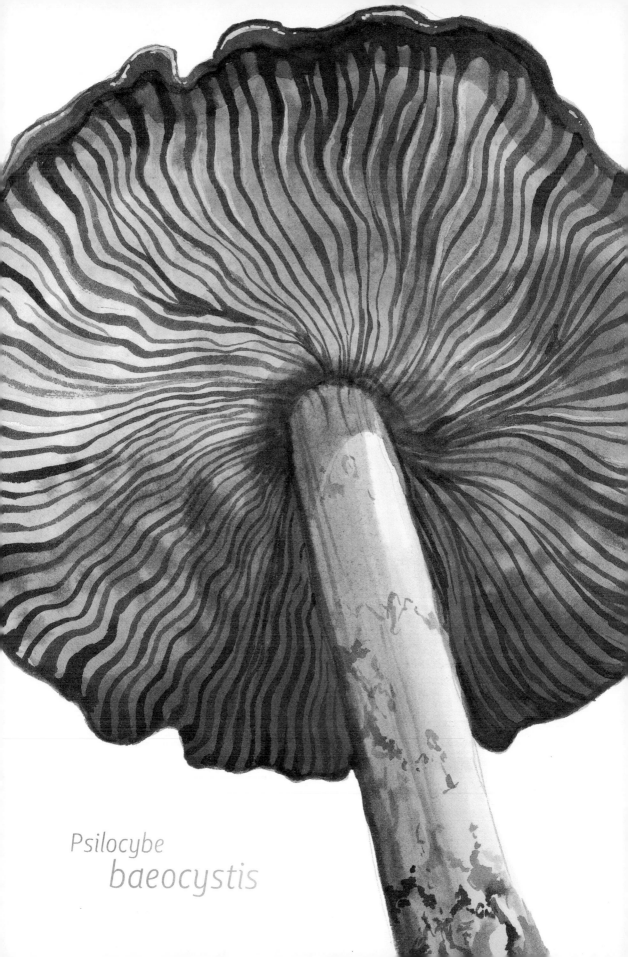

Psilocybe
baeocystis

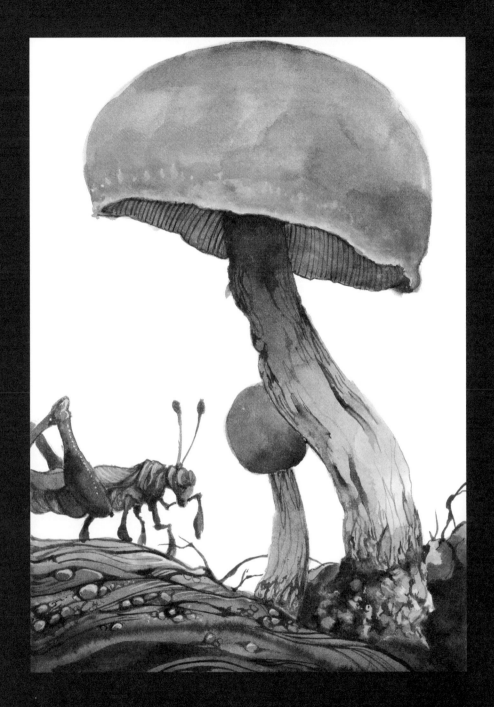

Psilocybe subaeruginosa

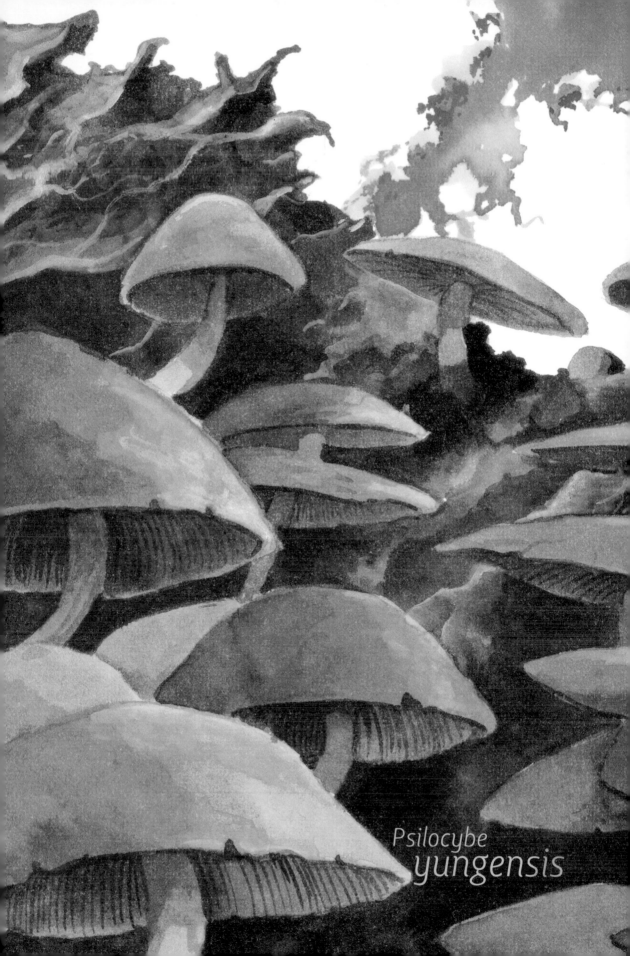

Psilocybe
yungensis

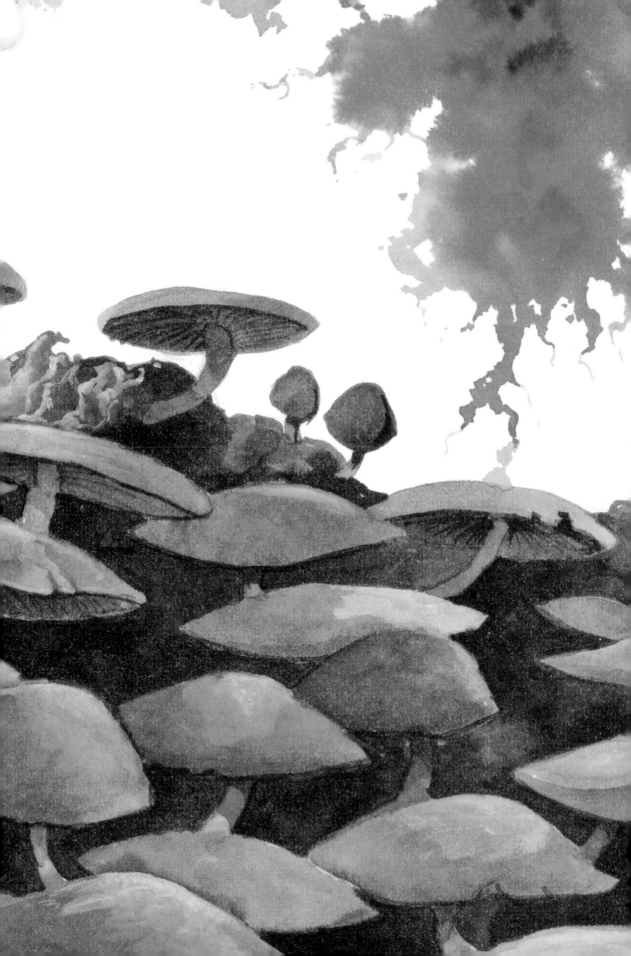

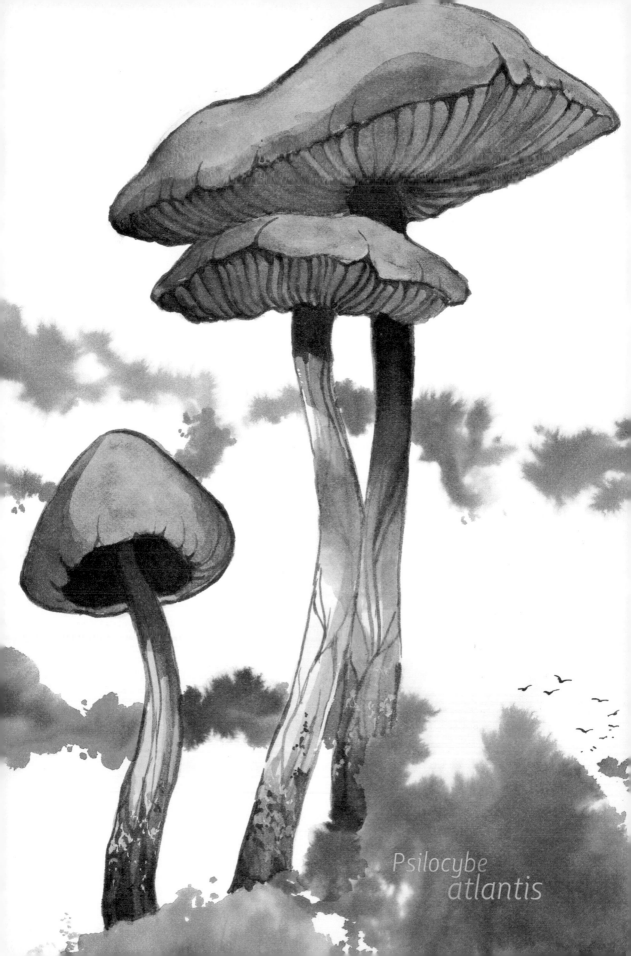

Psilocybe
atlantis

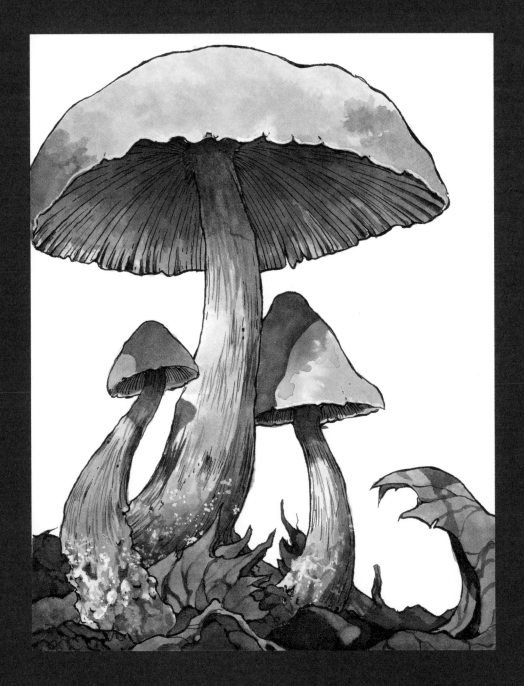

Psilocybe
argentipes

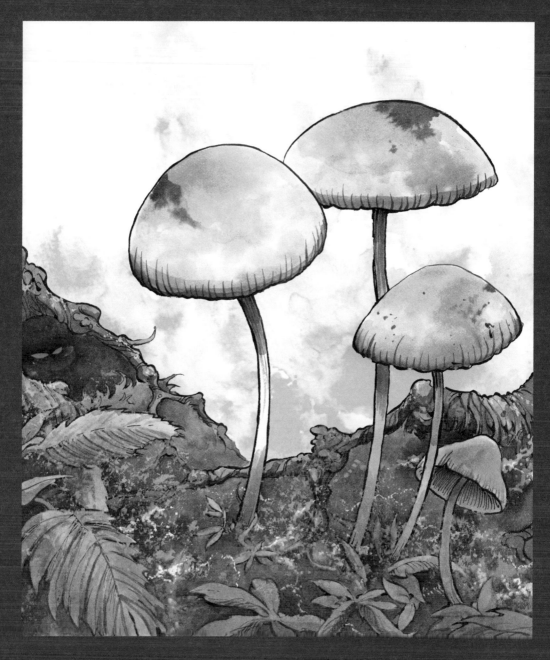

Psilocybe
bohemica

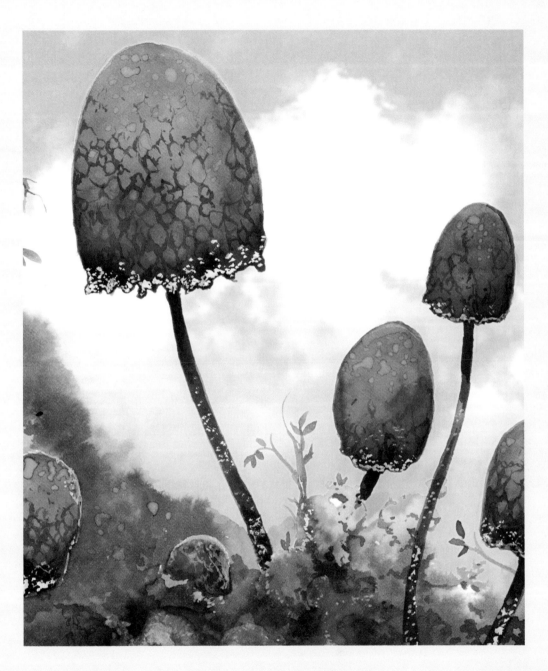

Psilocybe
angustispora

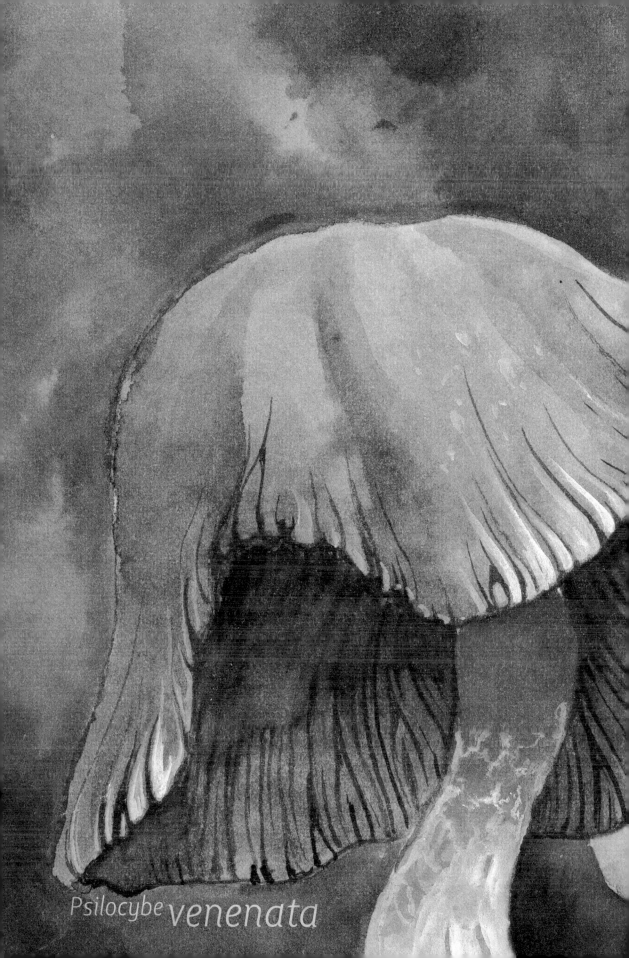

Psilocybe venenata

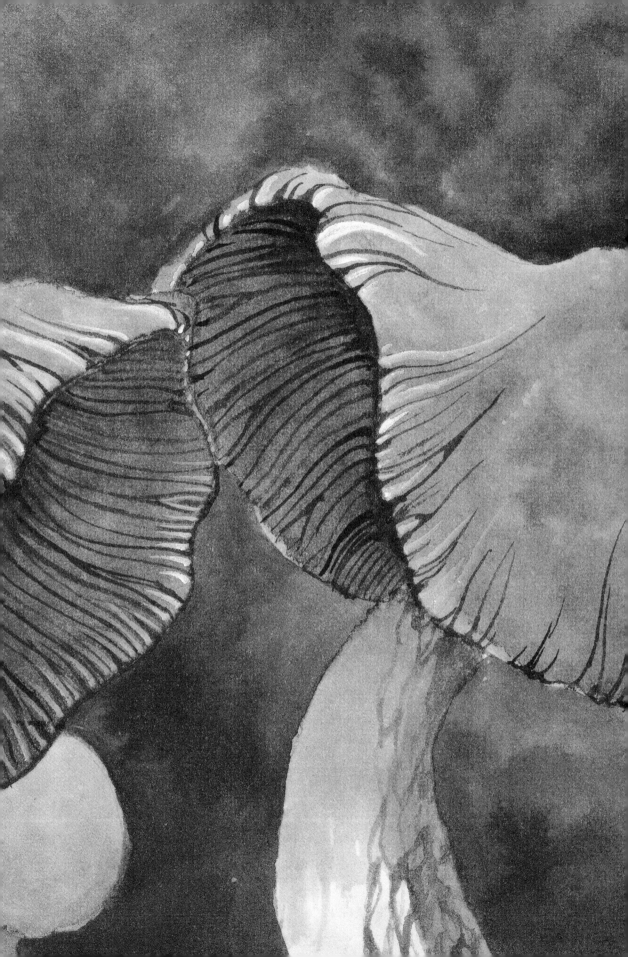

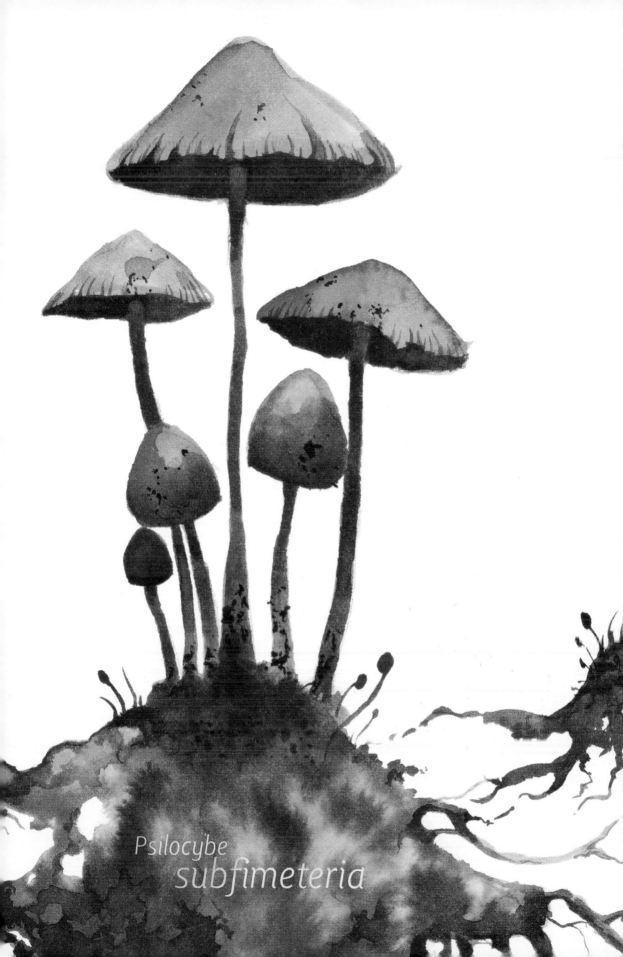

Psilocybe
subfimeteria

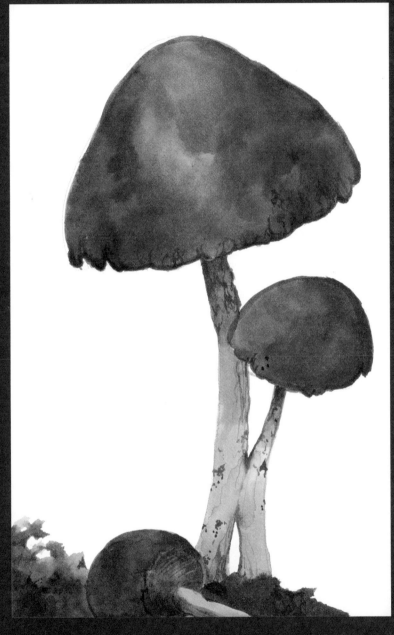

Psilocybe
silvatica

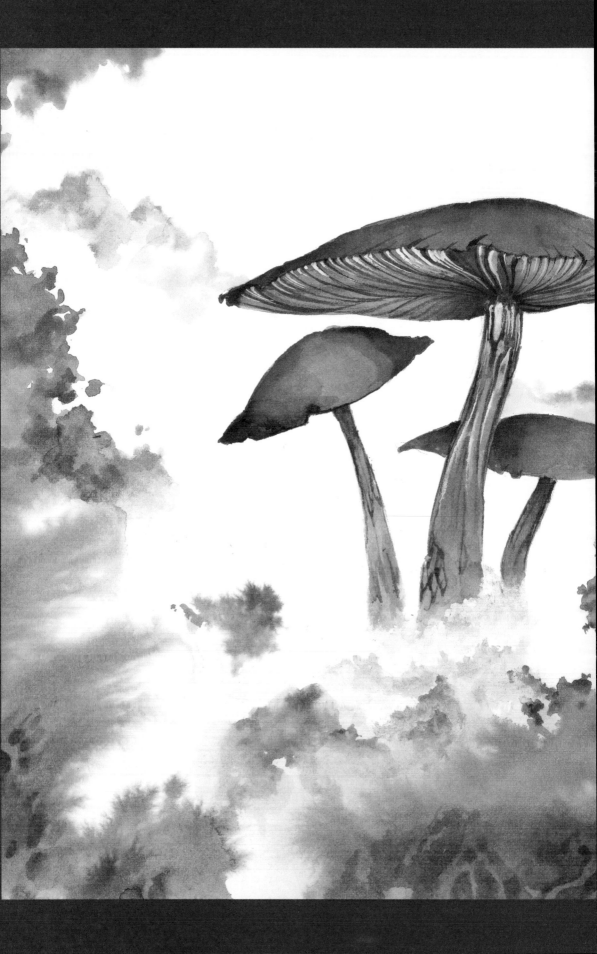

Psilocybe
azurescens

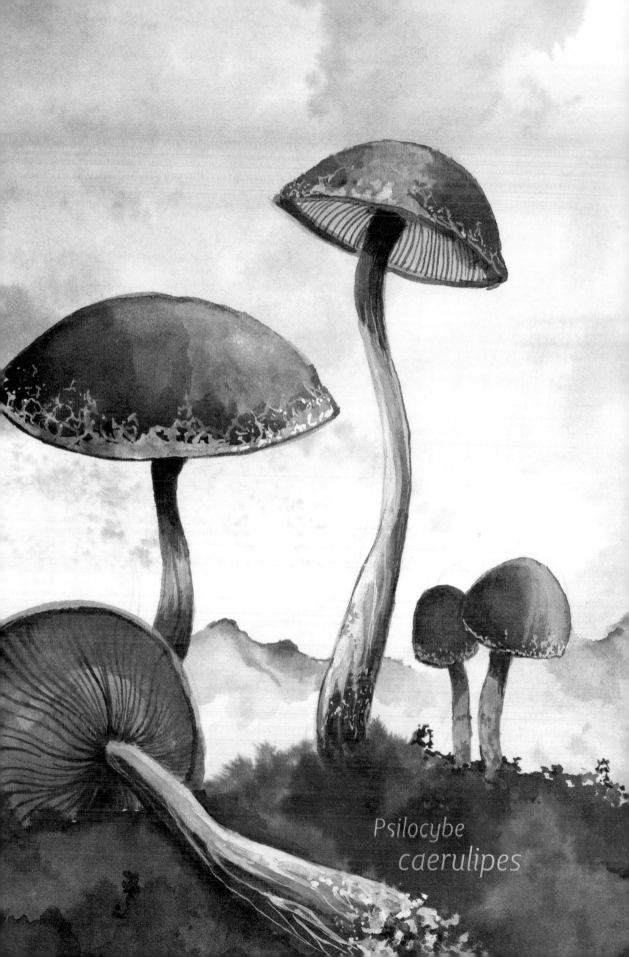

Psilocybe
caerulipes

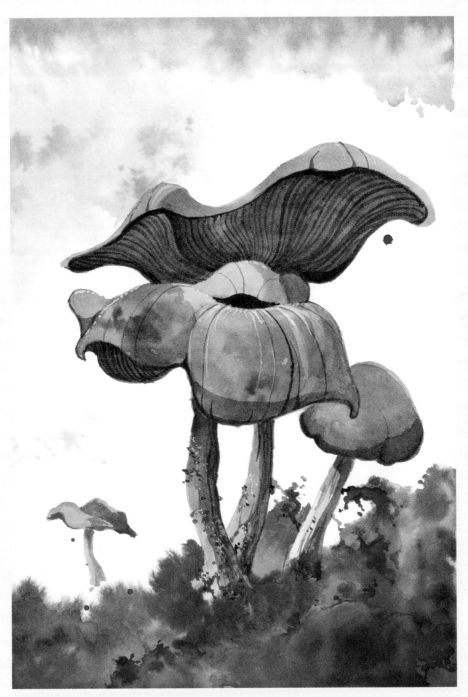

Psilocybe
caerulescens

Psilocybe caerulescens

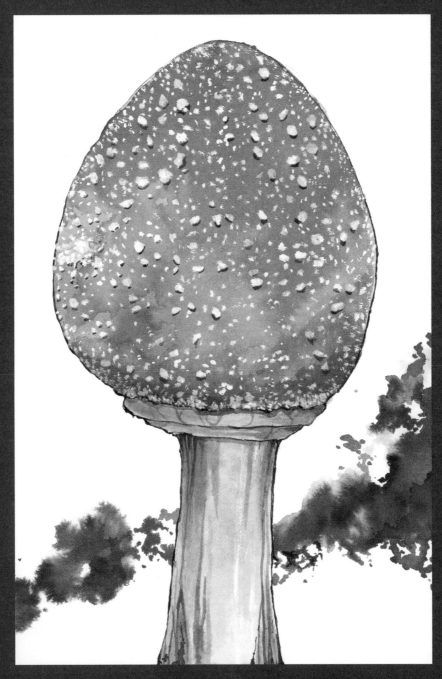

Psilocybe
cubensis

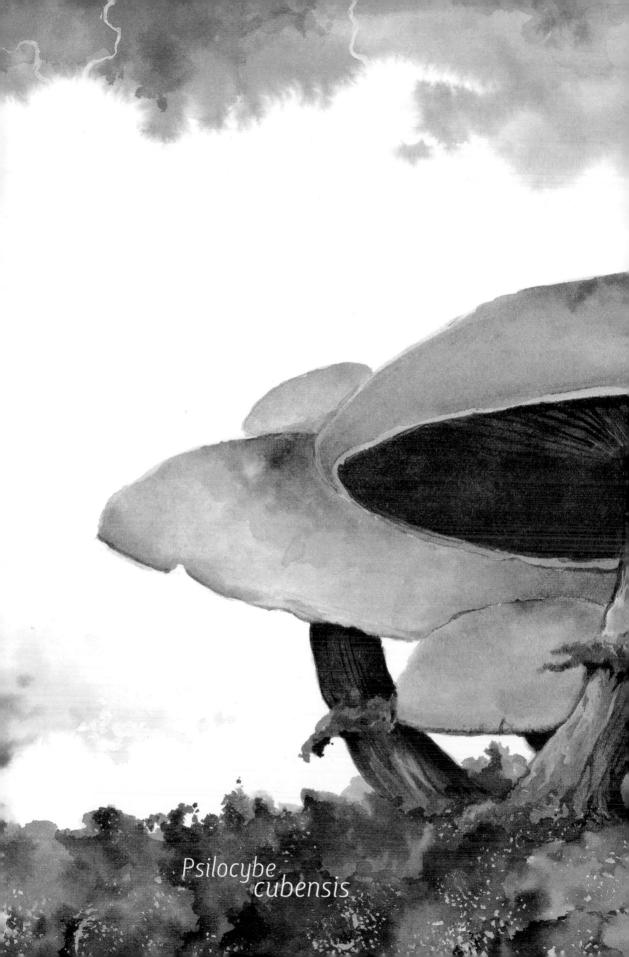

Psilocybe
cubensis

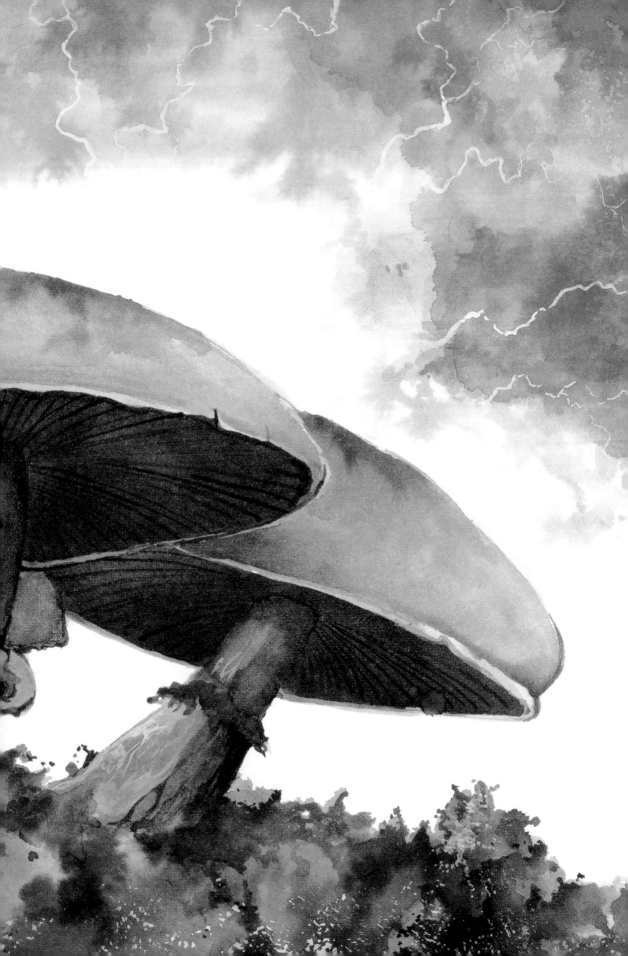

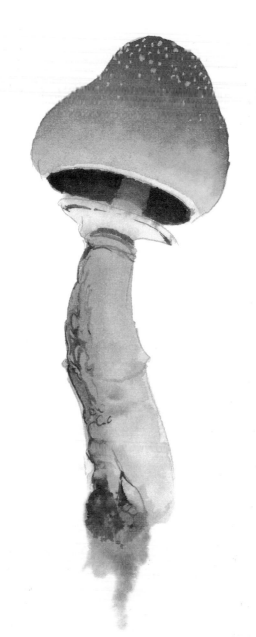

Psilocybe
cubensis

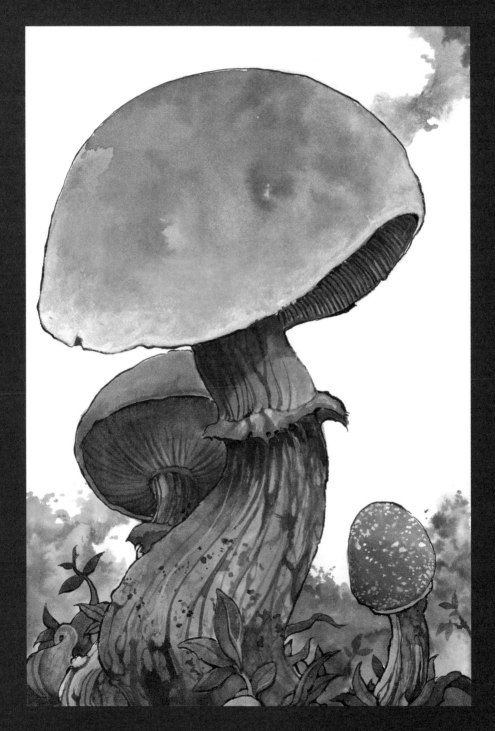

Psilocybe cubensis

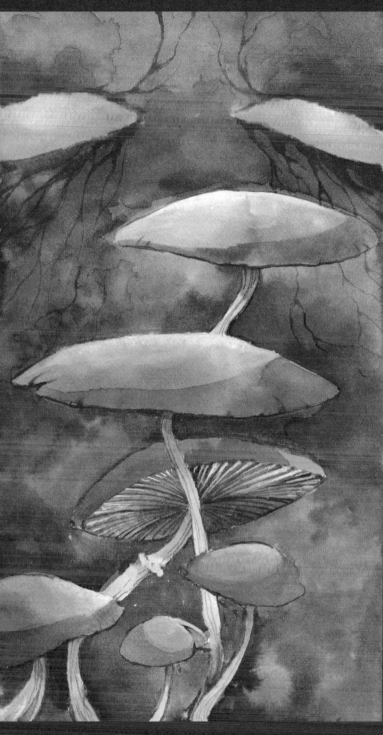

Psilocybe *cubensis*

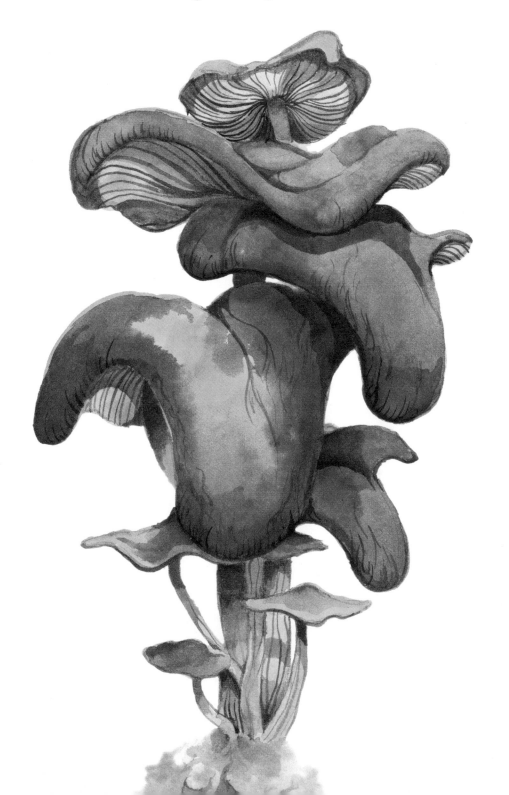

Psilocybe cyanescens

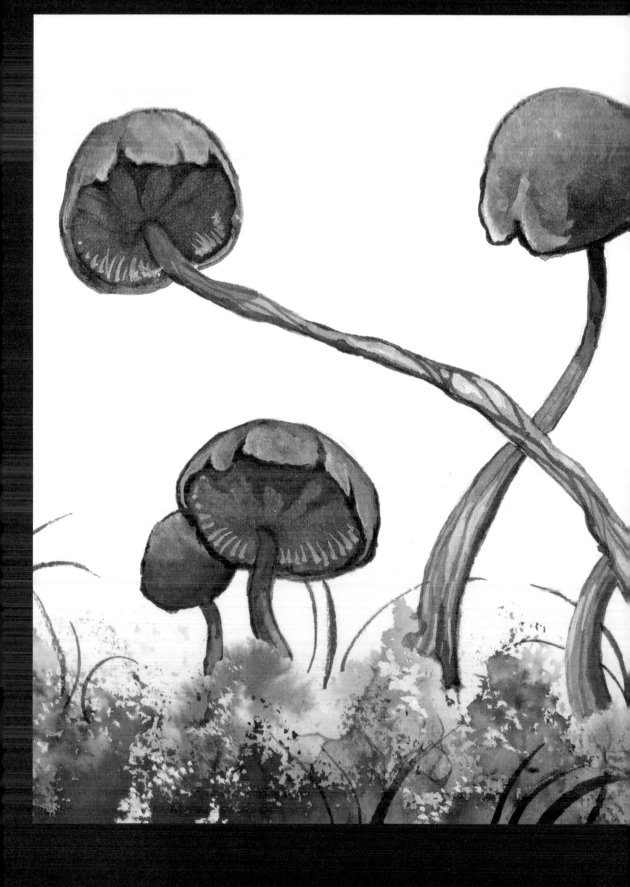

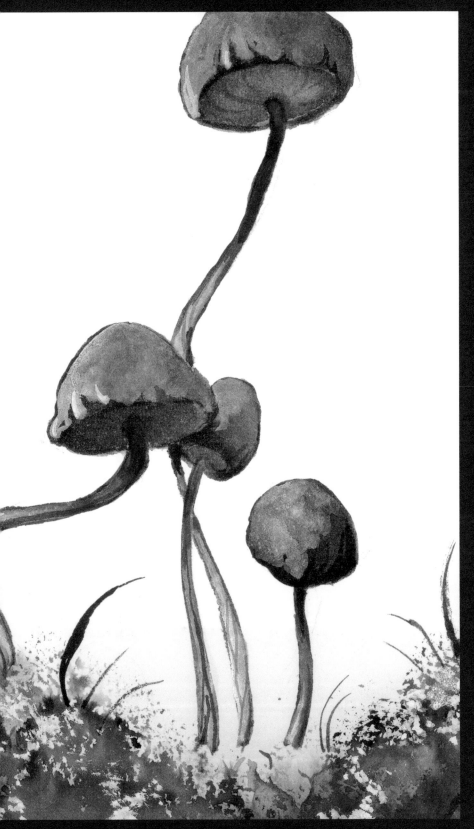

Psilocybe
herrerae

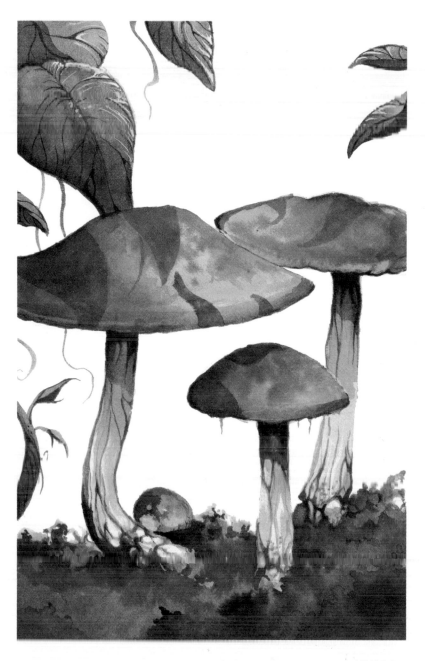

Psilocybe
cyanofibrillosa

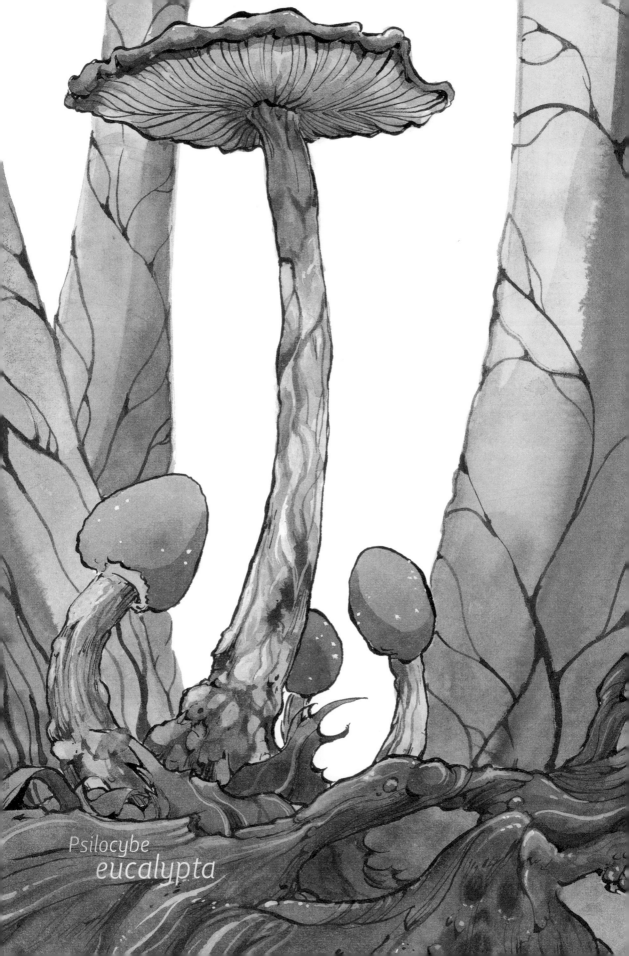

Psilocybe
eucalypta

Psilocybe
wassoniorum

Psilocybe
fimetaria

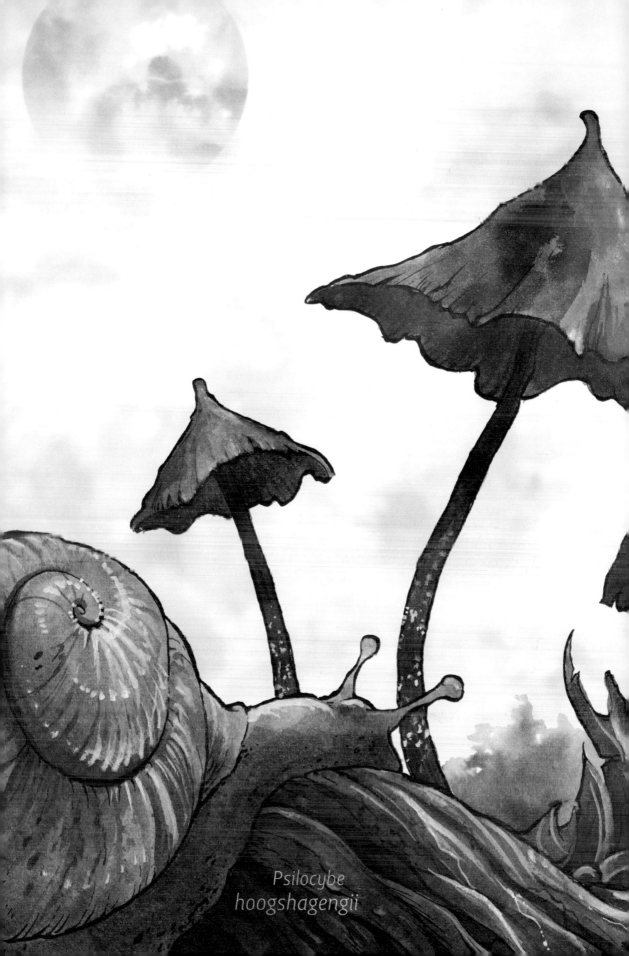

Psilocybe
hoogshagengii

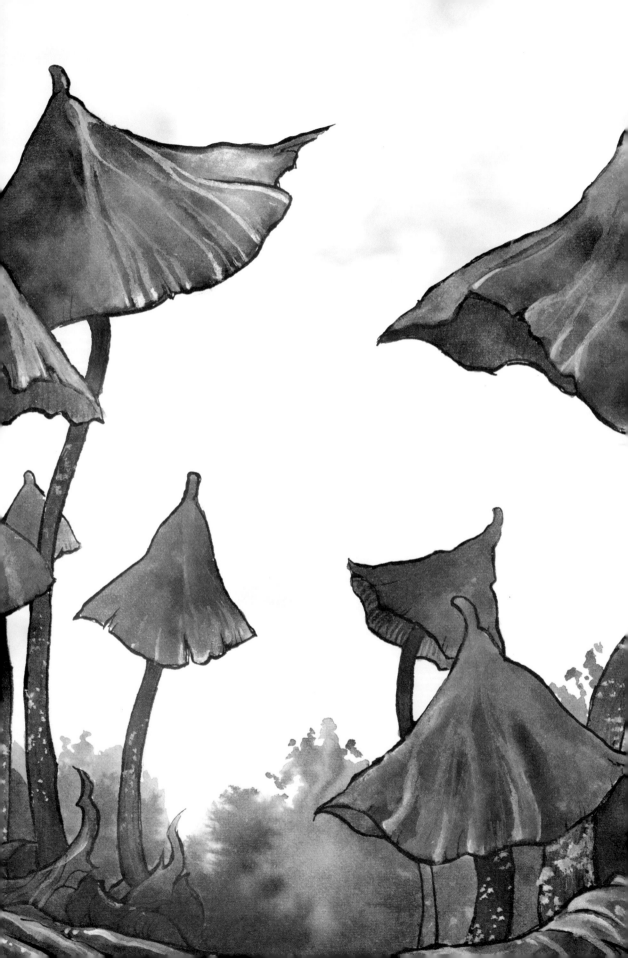

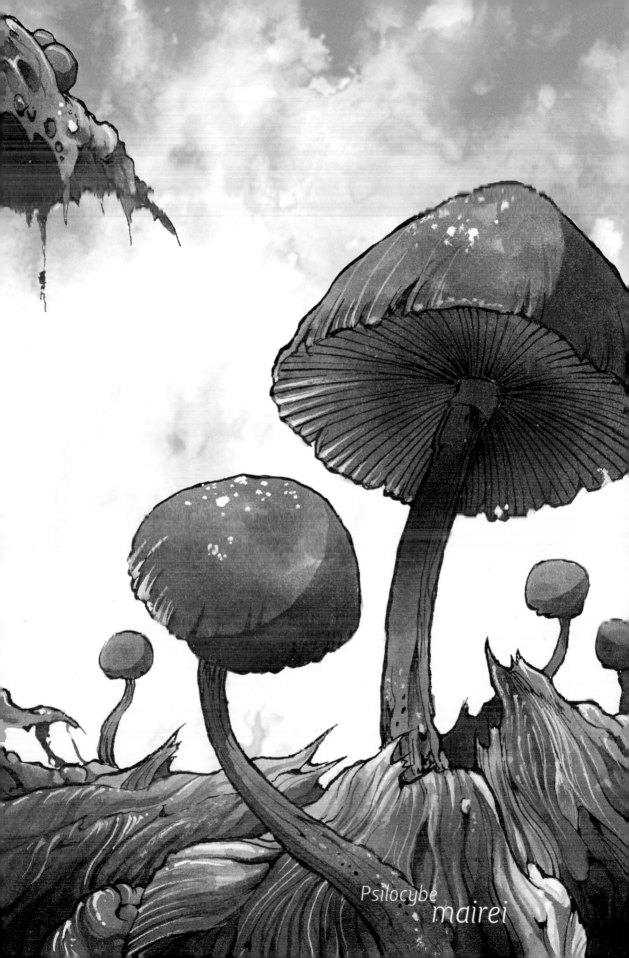

Psilocybe
mairei

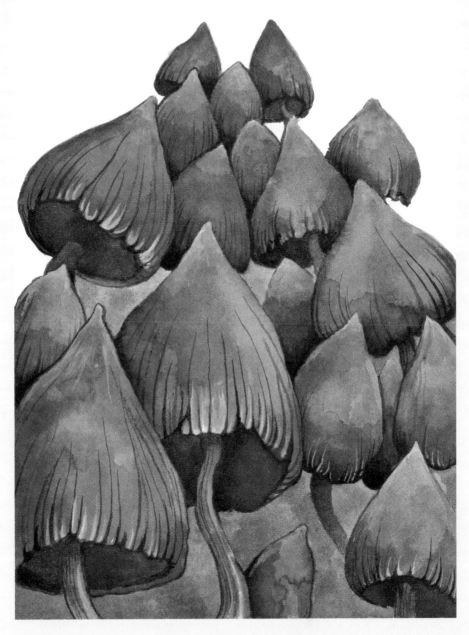

Psilocybe
mexicana

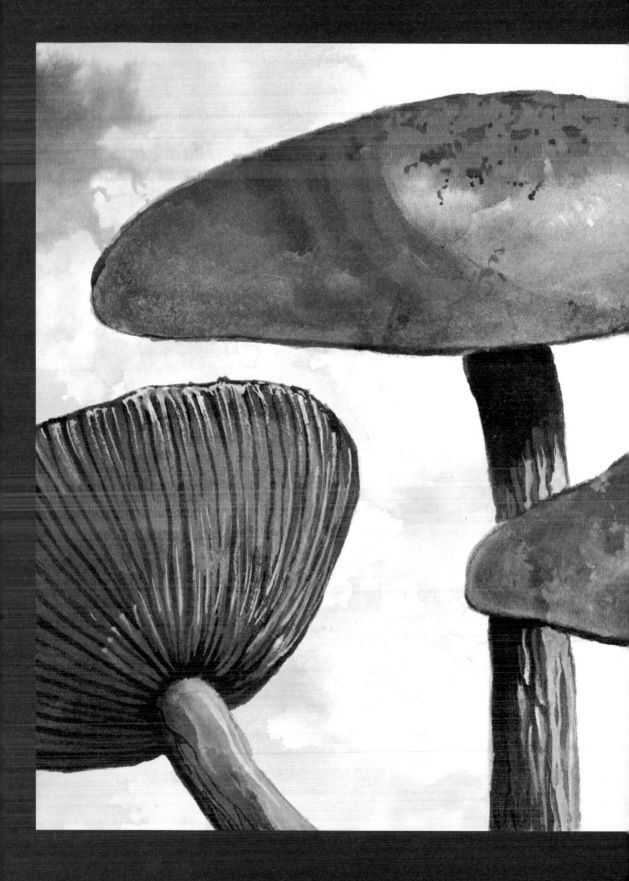

Psilocybe
luteonitens

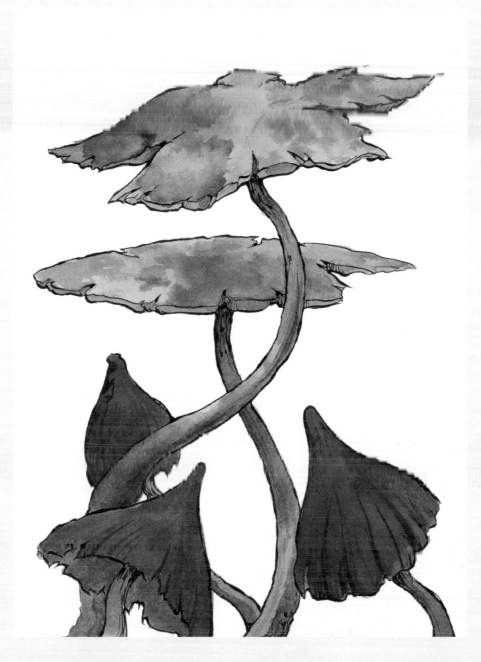

Psilocybe
muliericula (wassonii)

Psilocybe
natalensis

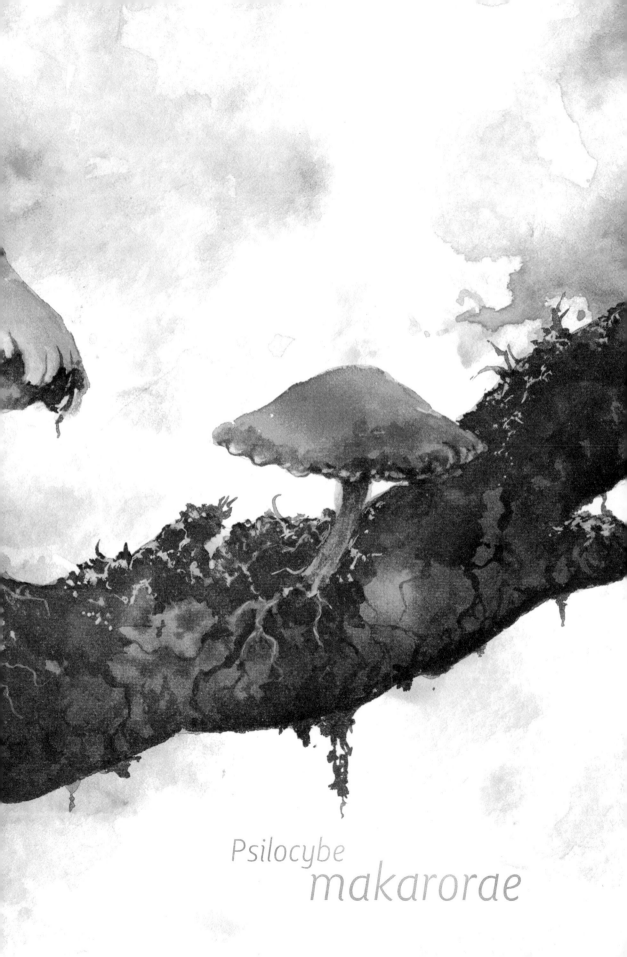

Psilocybe
makarorae

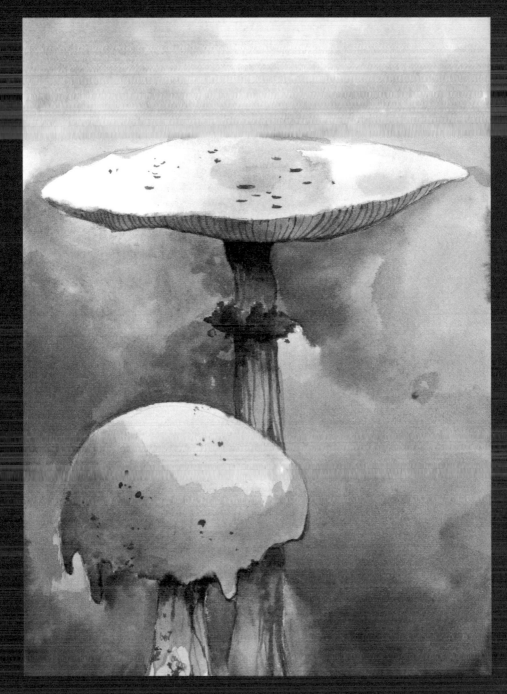

Psilocybe pseudocyanea

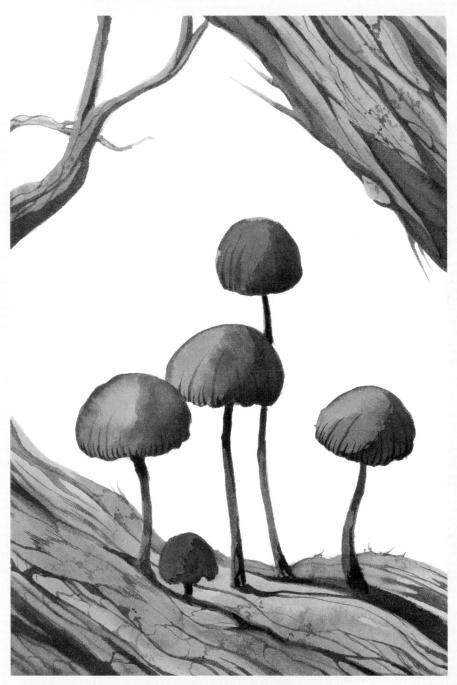

Psilocybe
quebecensis

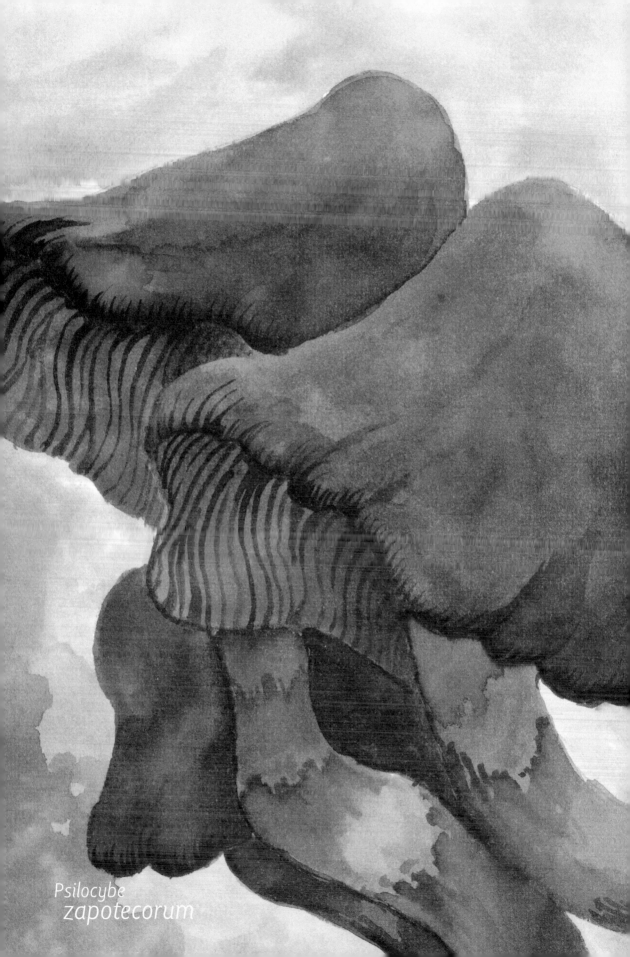

Psilocybe
zapotecorum

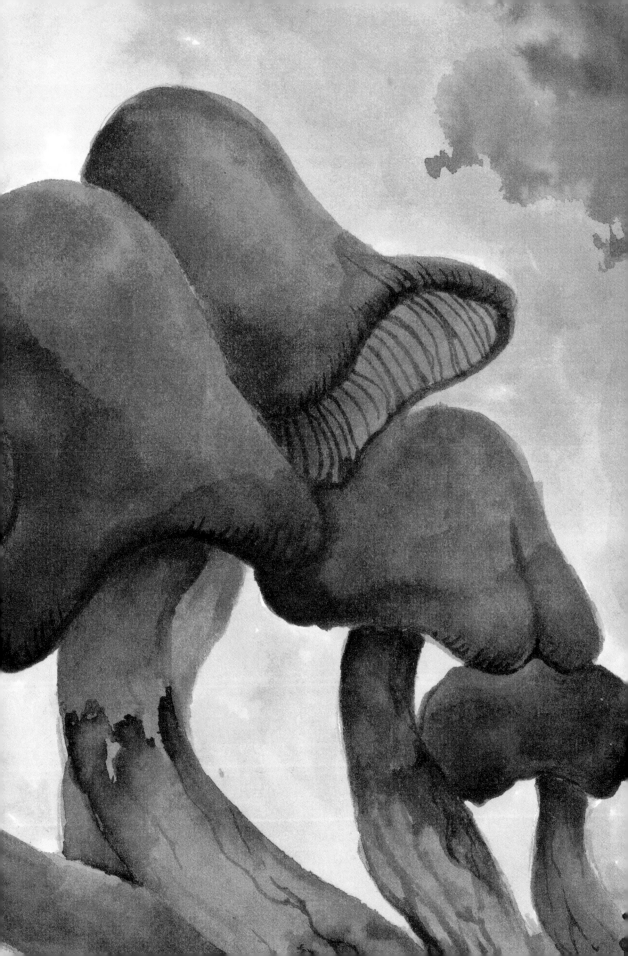

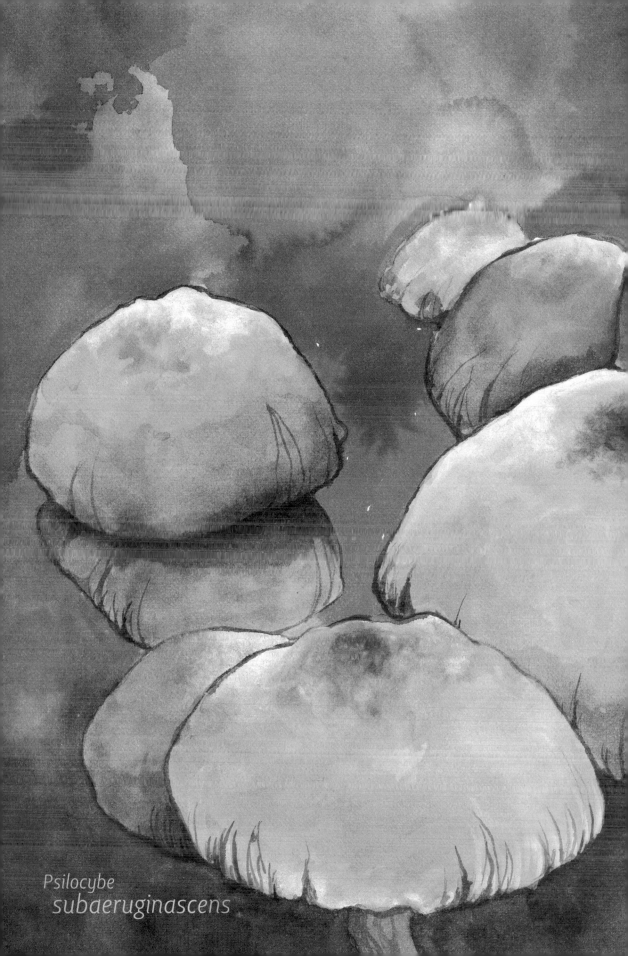

Psilocybe
subaeruginascens

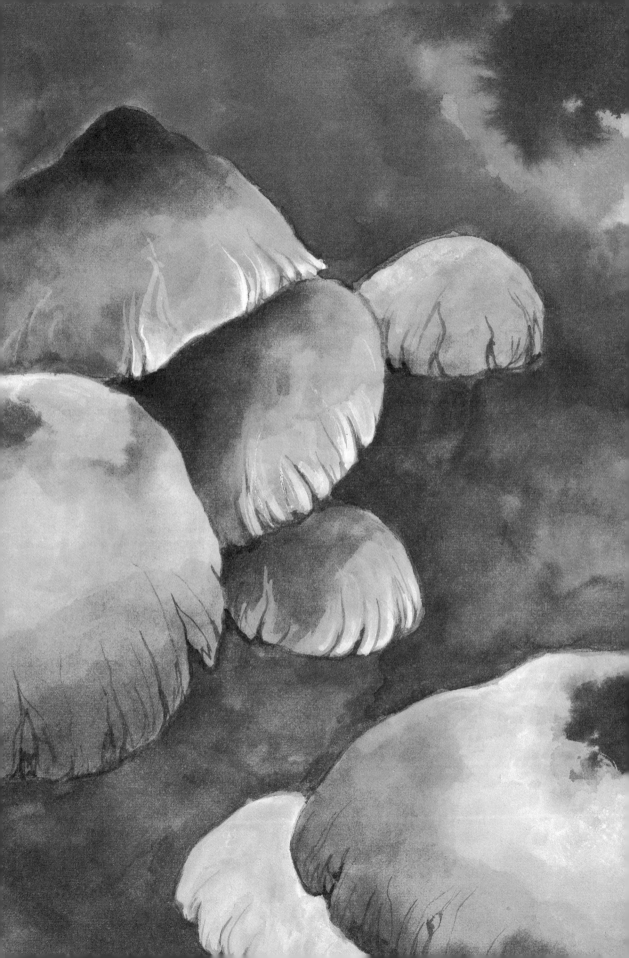

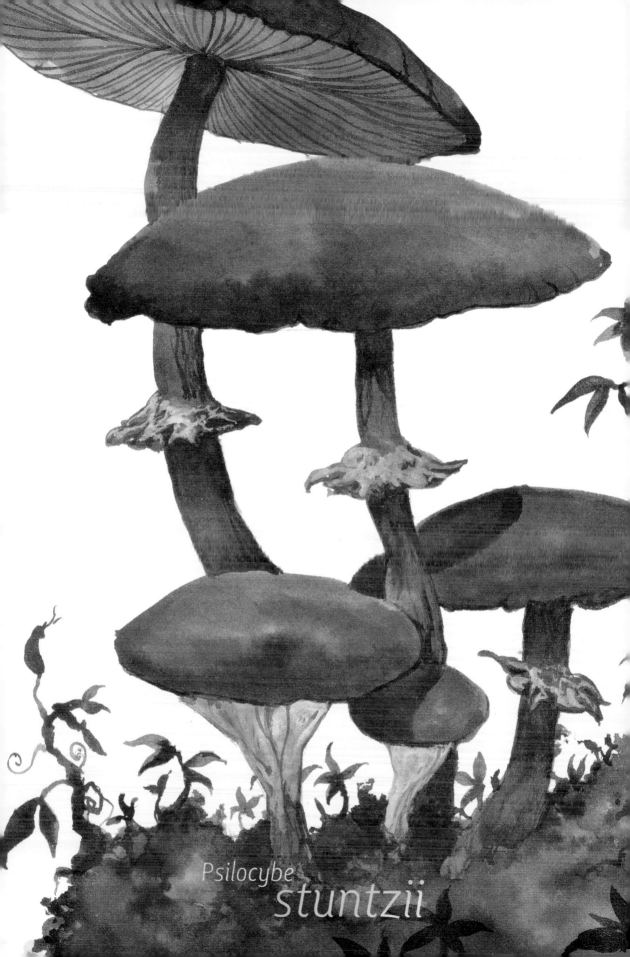

Psilocybe
stuntzii

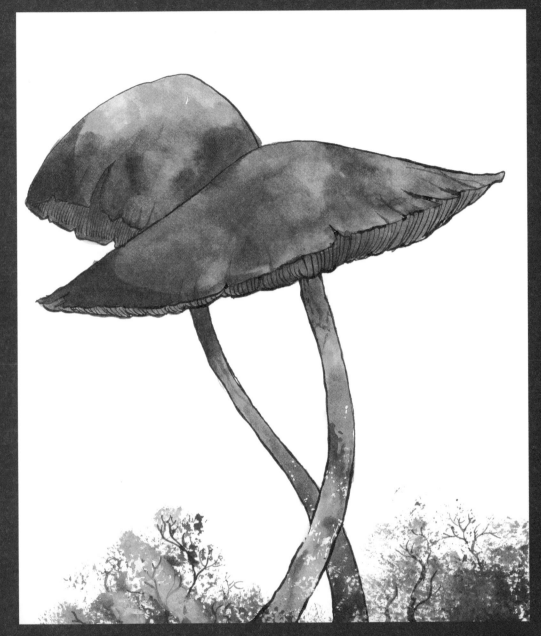

Psilocybe
brasiliensis

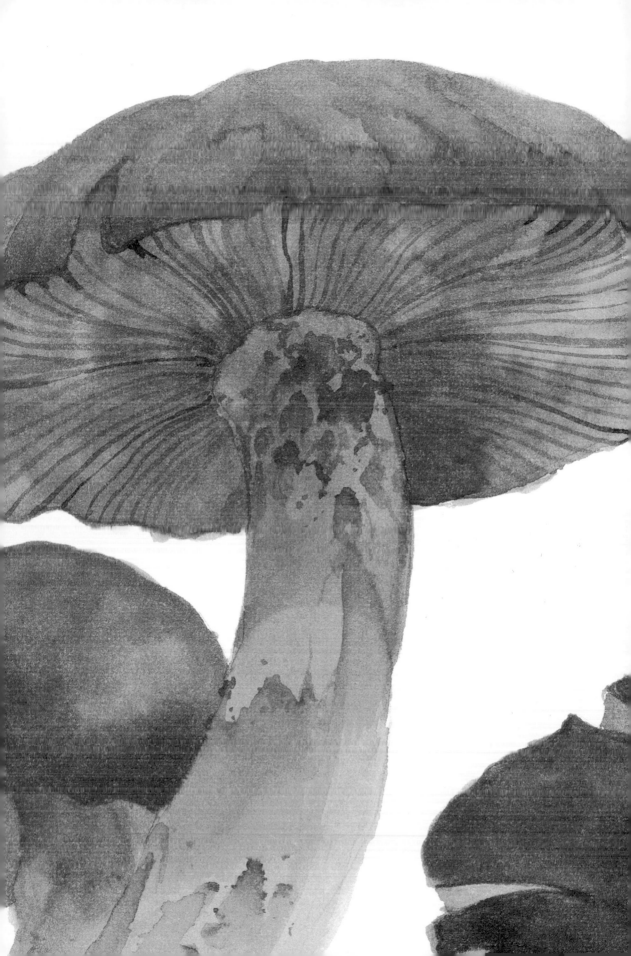

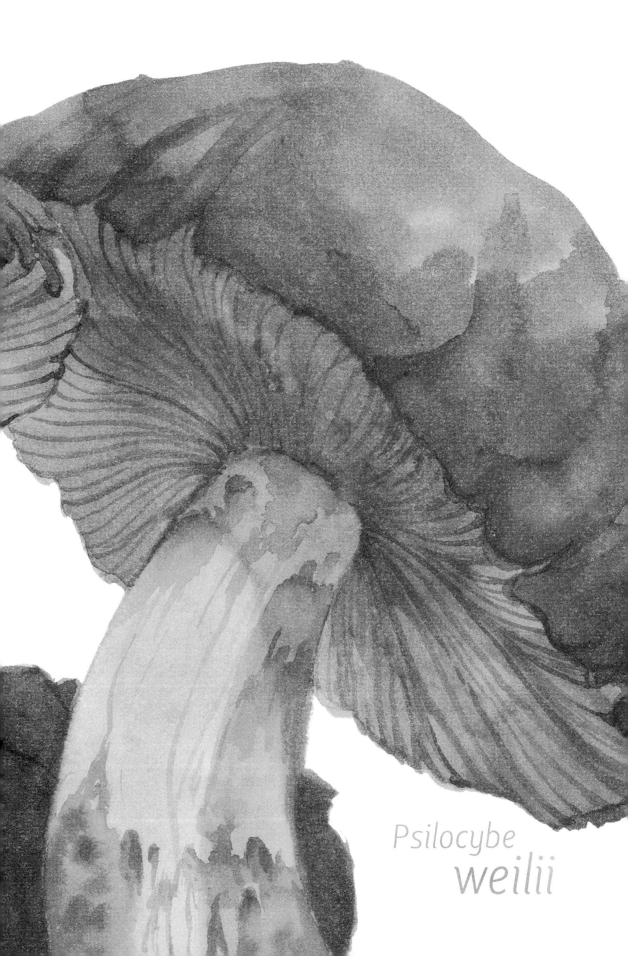

Psilocybe
weilii

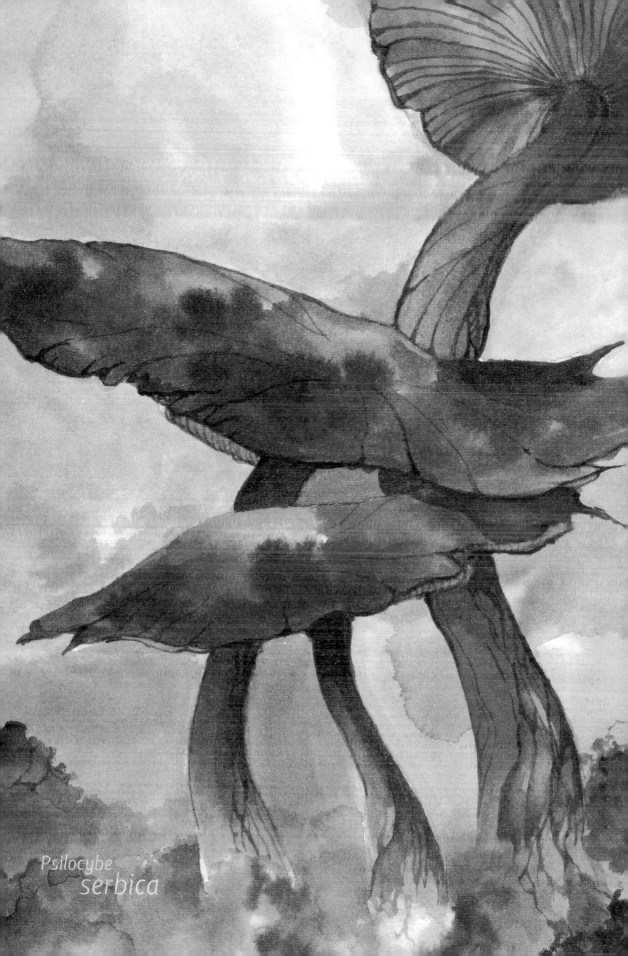

Psilocybe
serbica

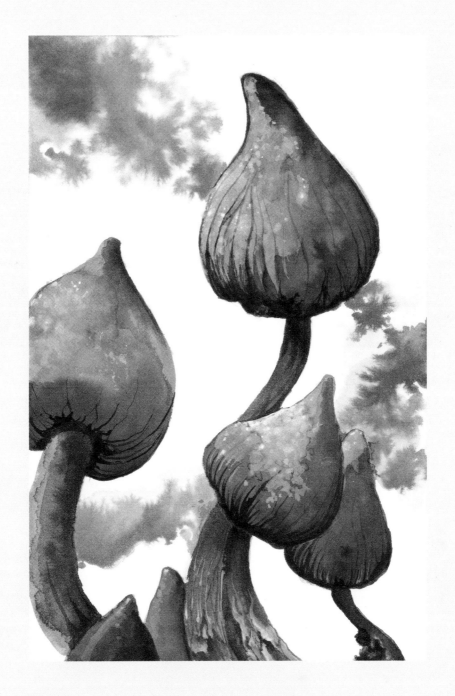

Psilocybe semilanceata

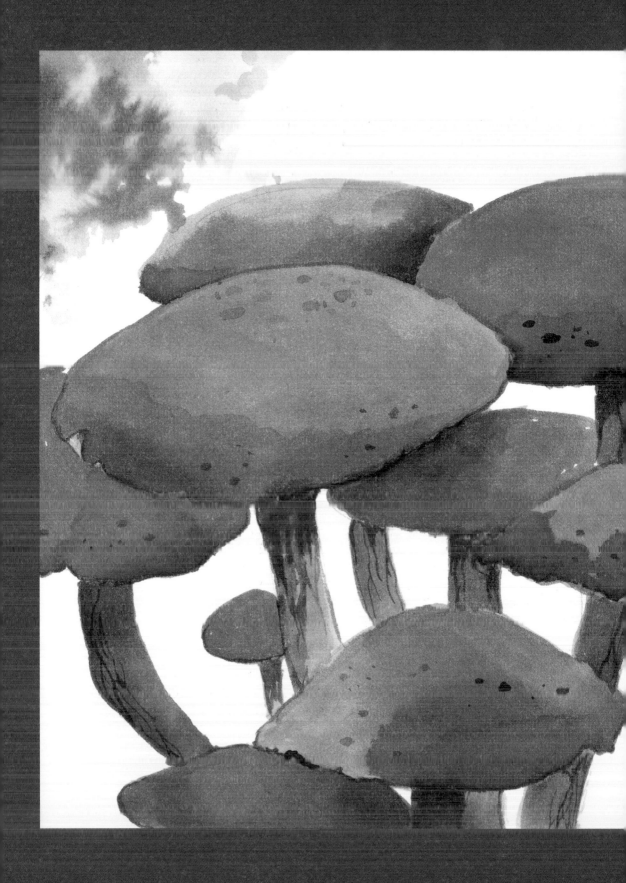

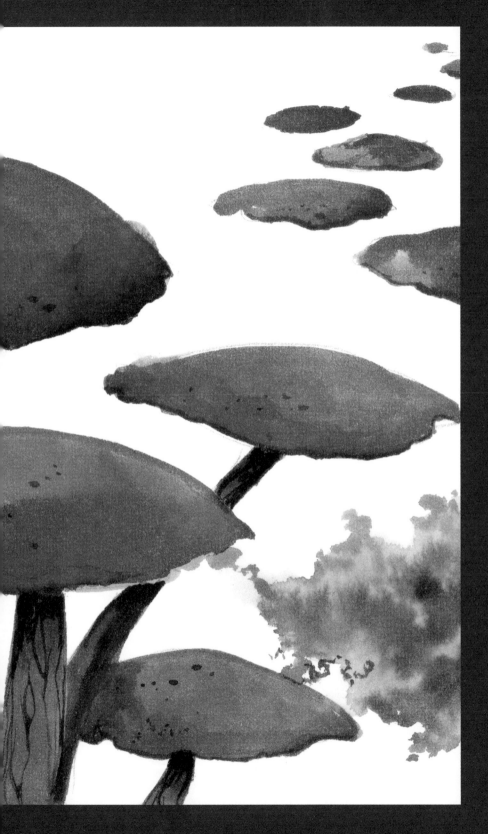

*Psilocybe
tampensis*

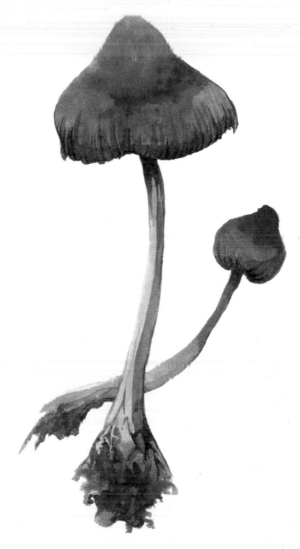

Psilocybe
samuiensis

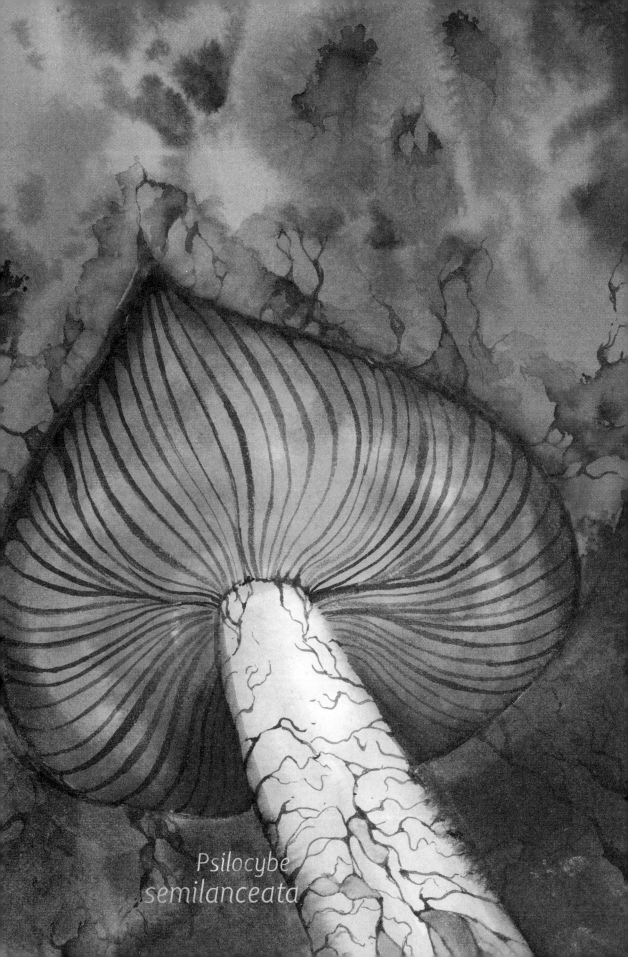

Psilocybe
semilanceata

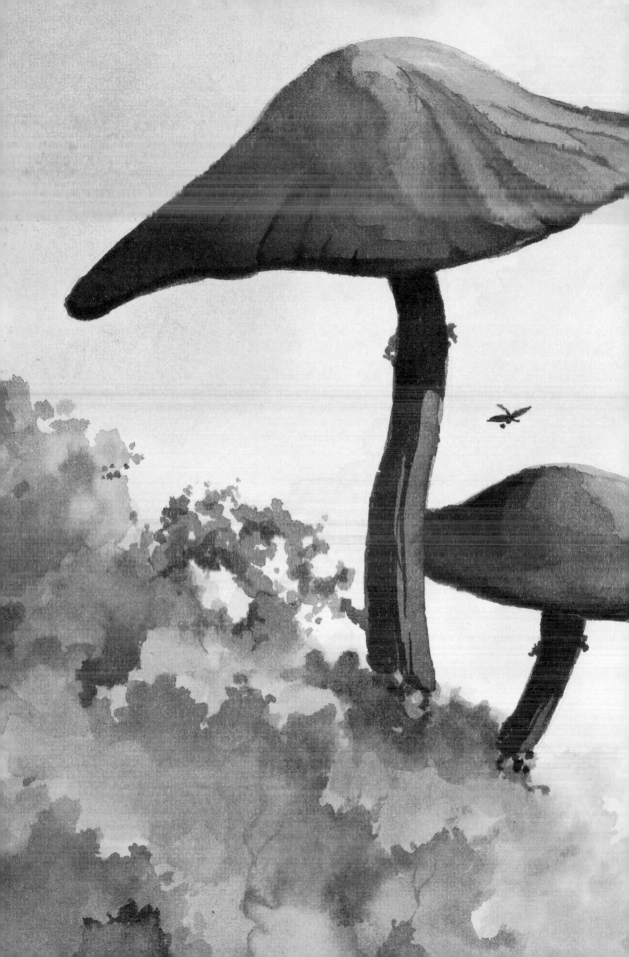

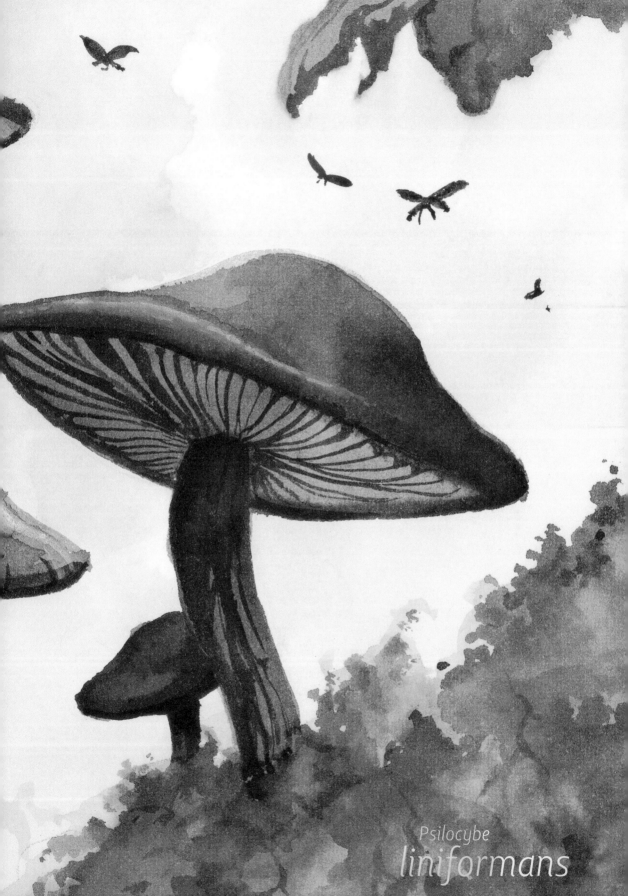

Psilocybe
liniformans

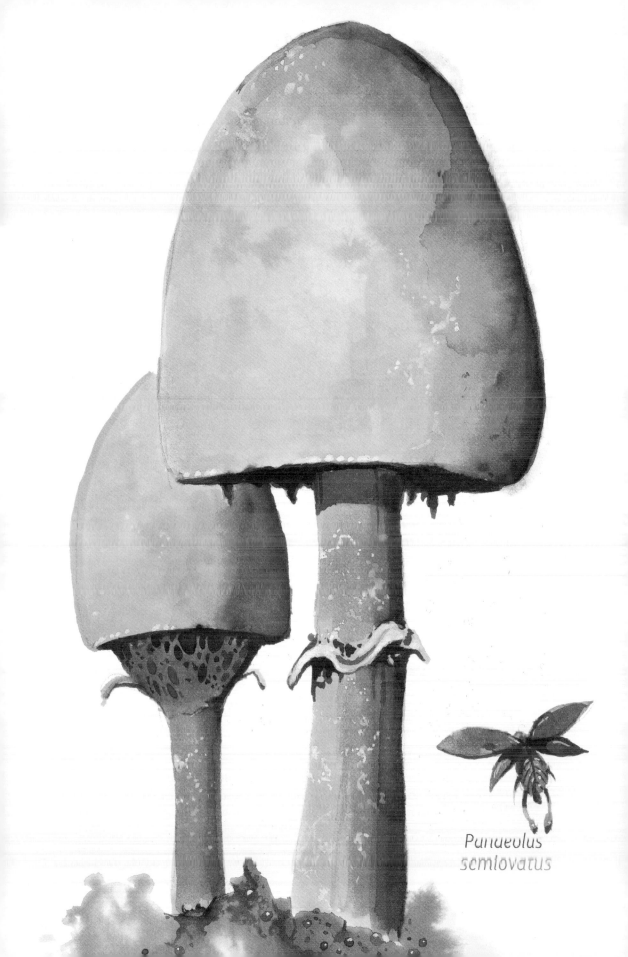

*Panaeolus
semiovatus*

Panaeolus is a name for a group of small,

dark, primarily dung inhabiting, gilled mushrooms. These mushrooms are

common in urban/suburban parks as well as in pastures, forests—wherever

horses, cows, deer, elk, or manure as fertilizer is found. These mushrooms

have an almost blackish gill color producing a black spore print. Panaeolus

can be divided into two groups—those that stain blue on bruising and those

that do not. Those that stain blue on bruising are sometimes referred to as

Copelandia instead of Panaeolus, but the species names are the same. Blue-

staining Panaeolus are much like blue-staining Psilocybes—they both contain

compounds that are psychoactive. The most conspicuous of these mushrooms

occur in the tropics. Along the Amazon River, wherever one finds cows put

out to graze, there should also be Panaeolus mushrooms rising out of the

dried cow dung in the grass. Some Panaeolus mushrooms are north temperate

in distribution, and a few of these that do not stain blue on bruising are

psychoactive anyway—they are just harder to identify because there is no easy

way to recognize them in the field.

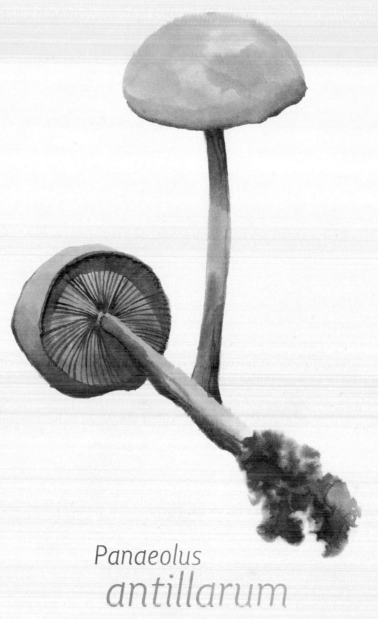

Panaeolus
antillarum

Panaeolus
africanus

Panaeolus fimicola

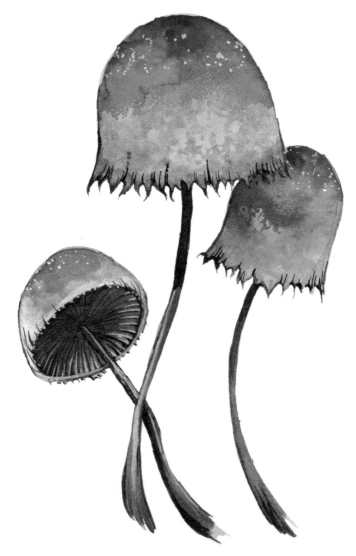

Panaeolus
papilionaceus

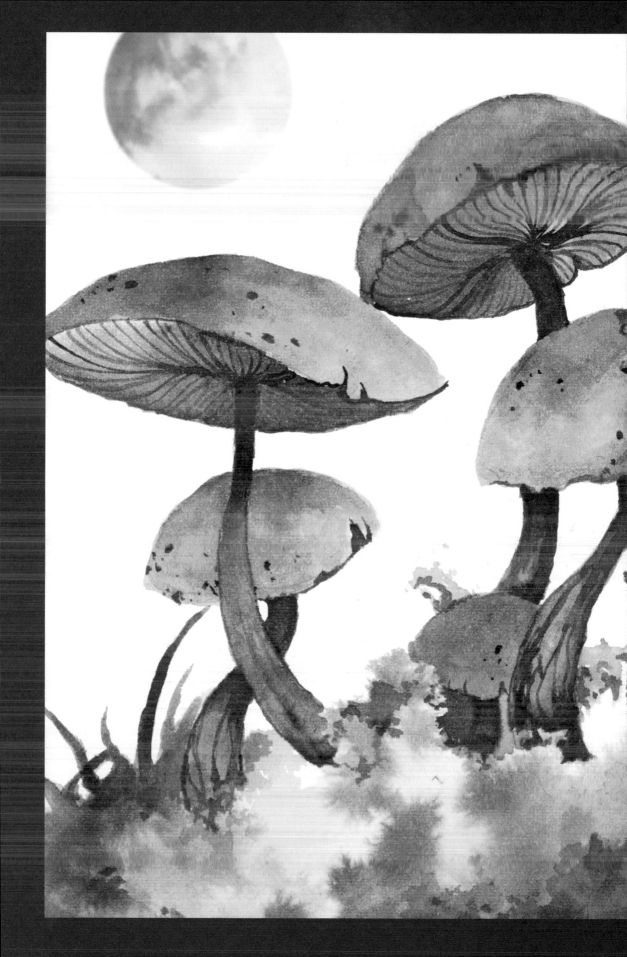

Panaeolus
cambodginiensis

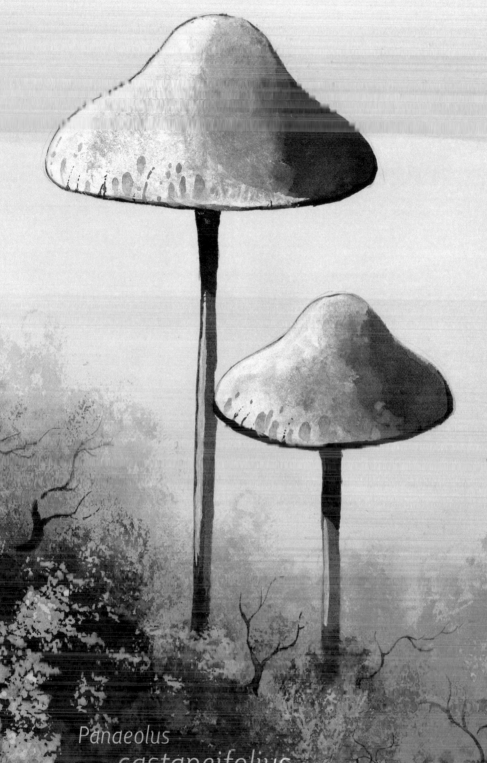

Panaeolus
castaneifolius

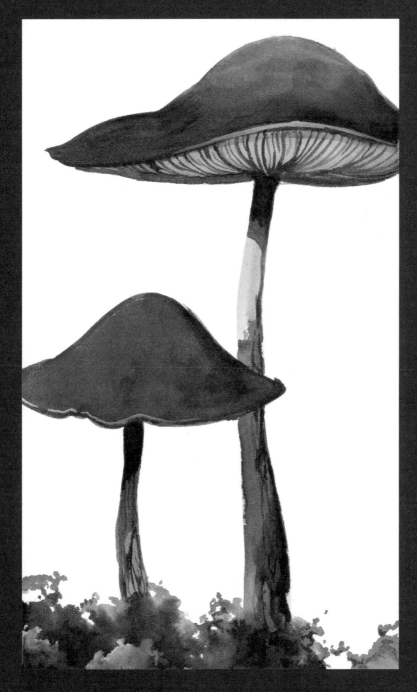

Panaeolus
acuminatus

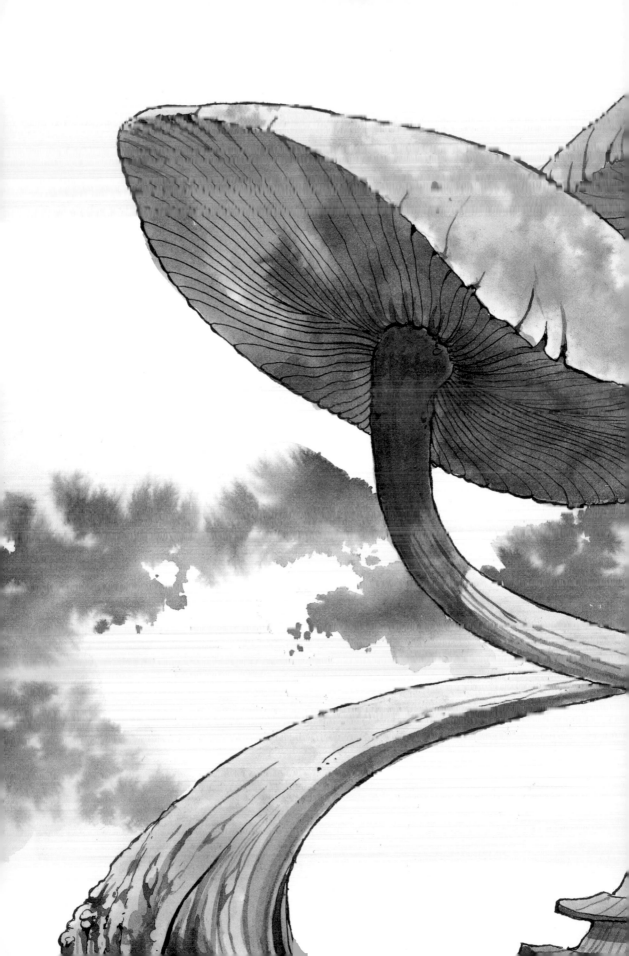

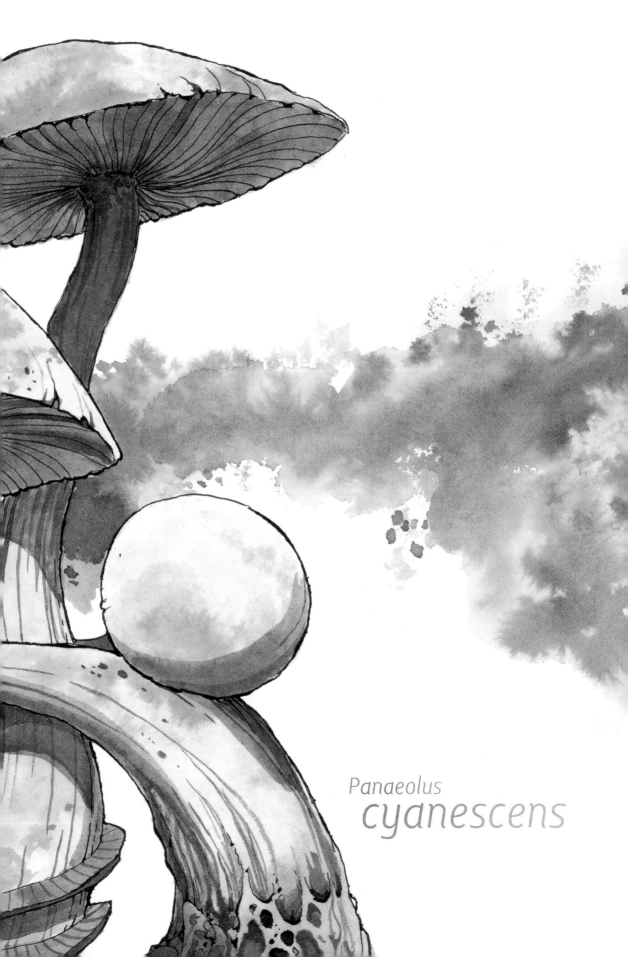

Panaeolus
cyanescens

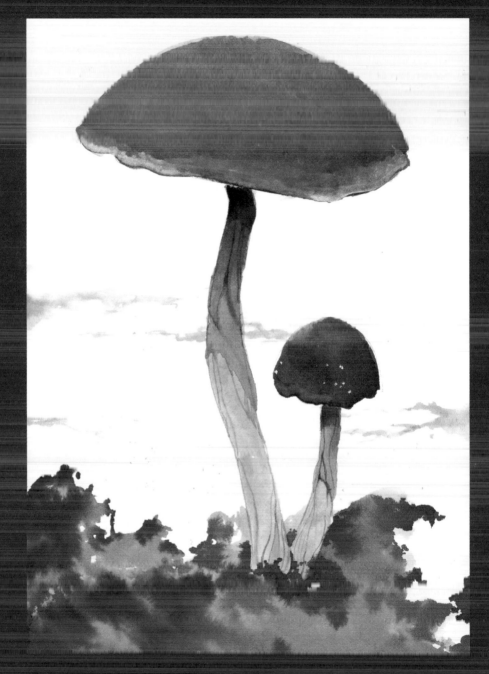

Panaeolus *fimicola*

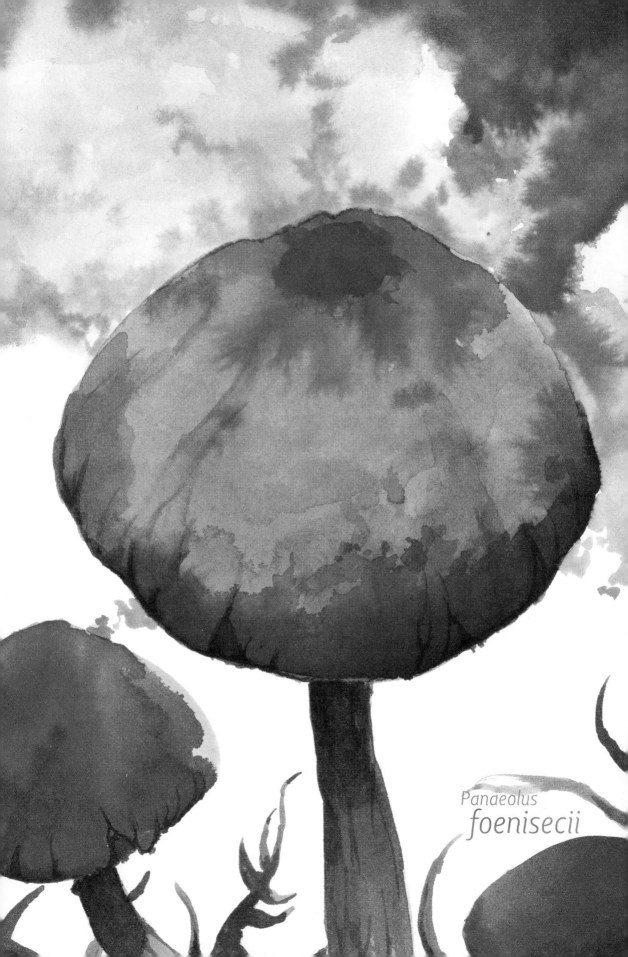

Panaeolus
foenisecii

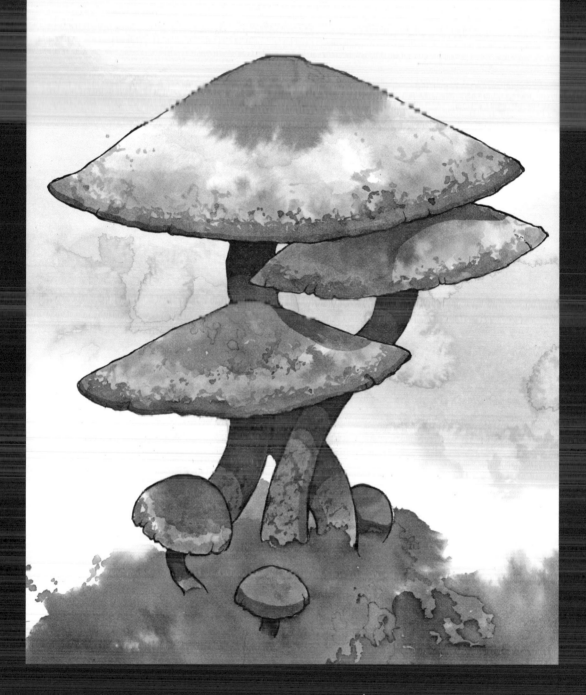

Panaeolus
subbalteatus

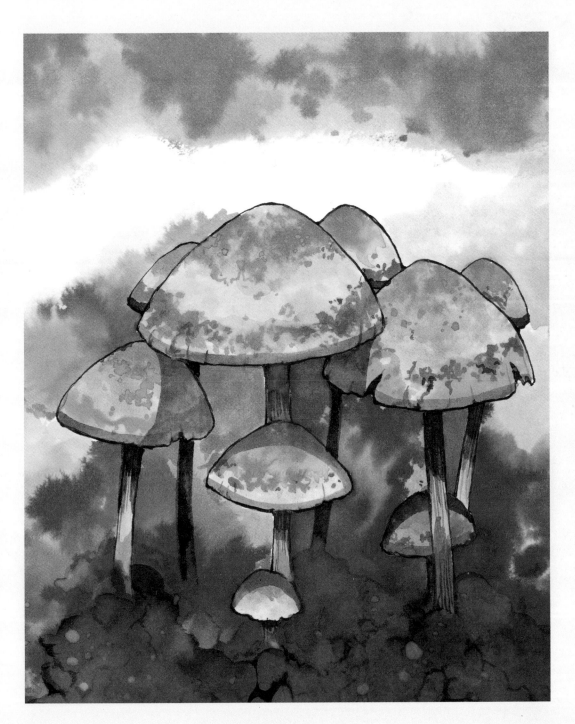

Panaeolus
koenisecii

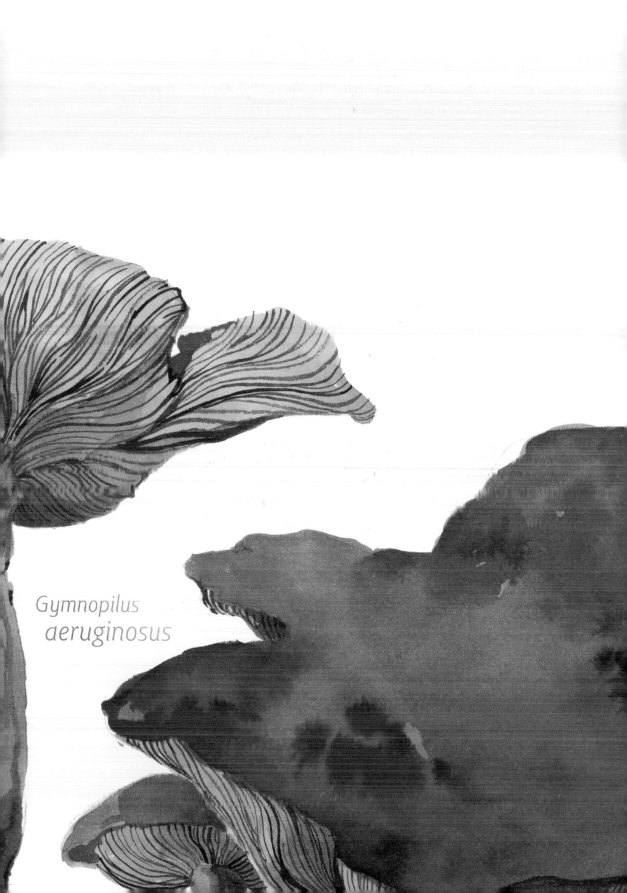

Gymnopilus aeruginosus

Big Laughing Gyms are large orange-

gilled mushrooms in the genus Gymnopilus that grow in clusters on wood. They have an overall orange color, a smooth cap, and a long, stout stem. They also have an orange annulus, or ring of tissue about the upper part of the stem. The gills produce an orange-brown spore print. These large mushrooms occur in the late summer and fall across North America and parts of Europe, Asia, and Japan. They are as common in city parks as they are in wooded areas in suburbia—they can be found in almost any place where there are broad-leaved trees. These mushrooms can appear in small clusters of a dozen or so, or in groups numbering upward of fifty, although usually only a few in any cluster will grow to a large size. Some populations have a distinct anise odor, while others just smell mushroomy. All are intensely bitter whether tasted raw or cooked, which is why they are not likely to be mistaken for edibles. There are small species of Gymnopilus—those with caps only about an inch across and thin, slender stems. But only the large species (two- to four-inch caps) with rings on their stems are even potentially psychoactive. Since they are so bitter, those who ingest them first dry them, then eat them as chips covered with something sweet like strawberry preserves. Unlike Psilocybes that can produce "visions," the response to Big Laughing Gyms is a couple of hours of unprovoked hilarity.

Care must be taken not to mistake Big Laughing Gyms with the deadly species of Galerina, little brown mushrooms that grow on wood or in grass and have a ring on their stem. Deadly Galerinas contain the same lethal toxins as the Destroying Angel Amanitas.

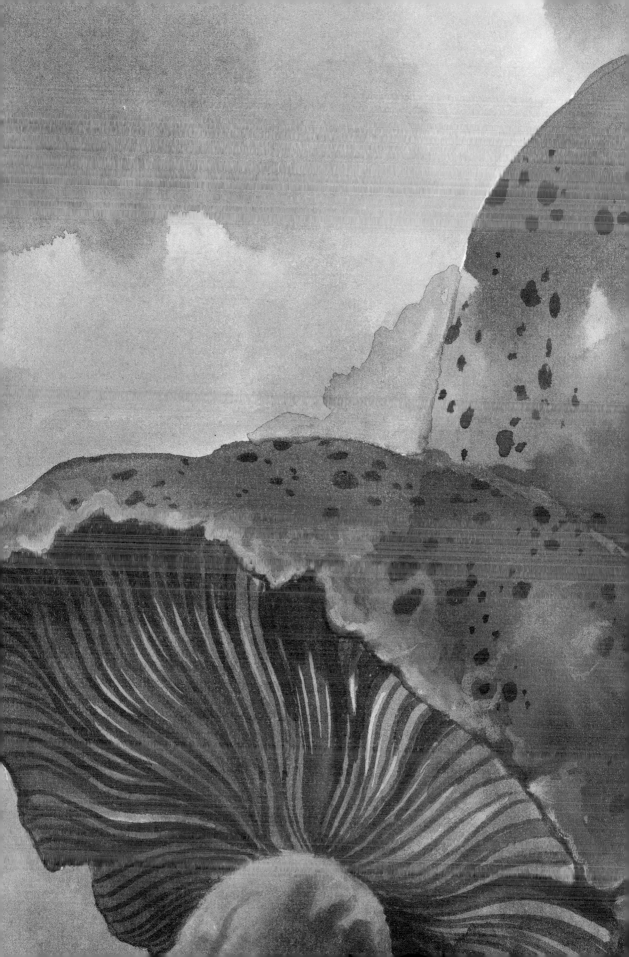

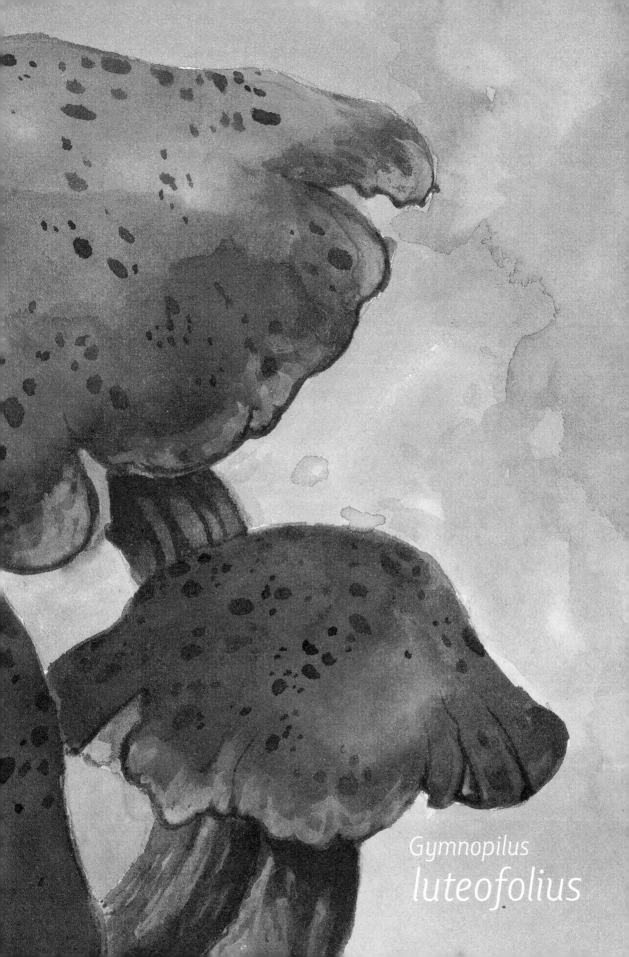

Gymnopilus
luteofolius

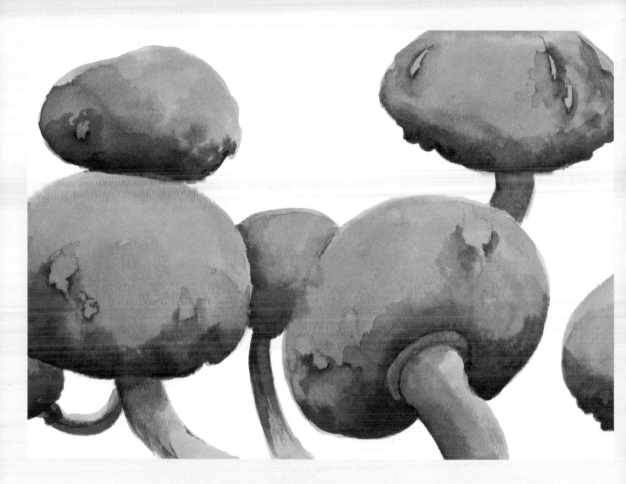

Gymnopilus
spectabilis

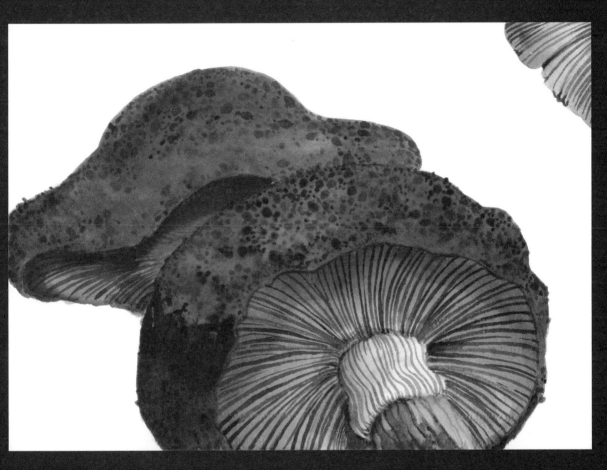

Gymnopilus
luteolius

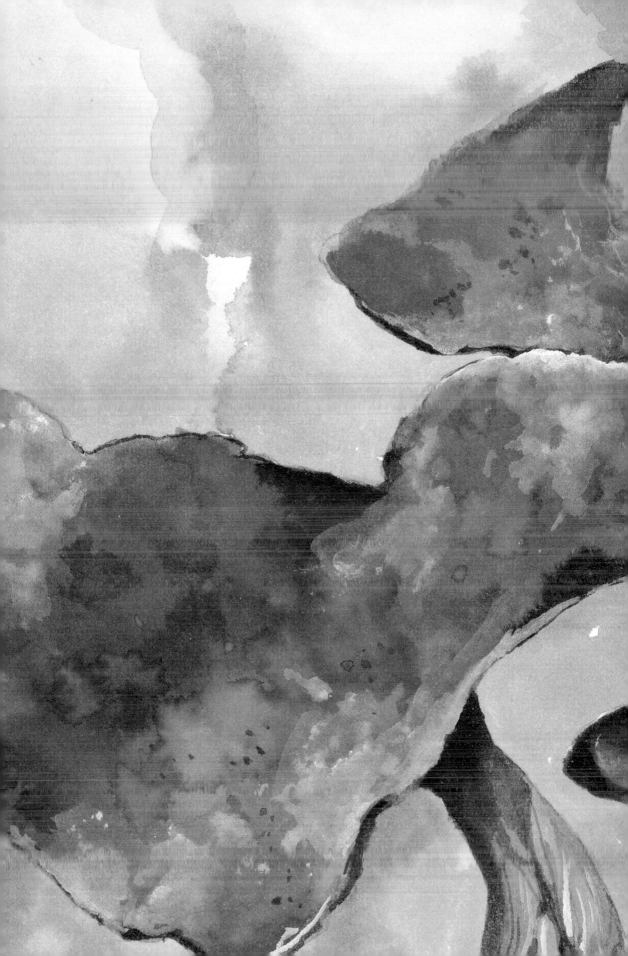

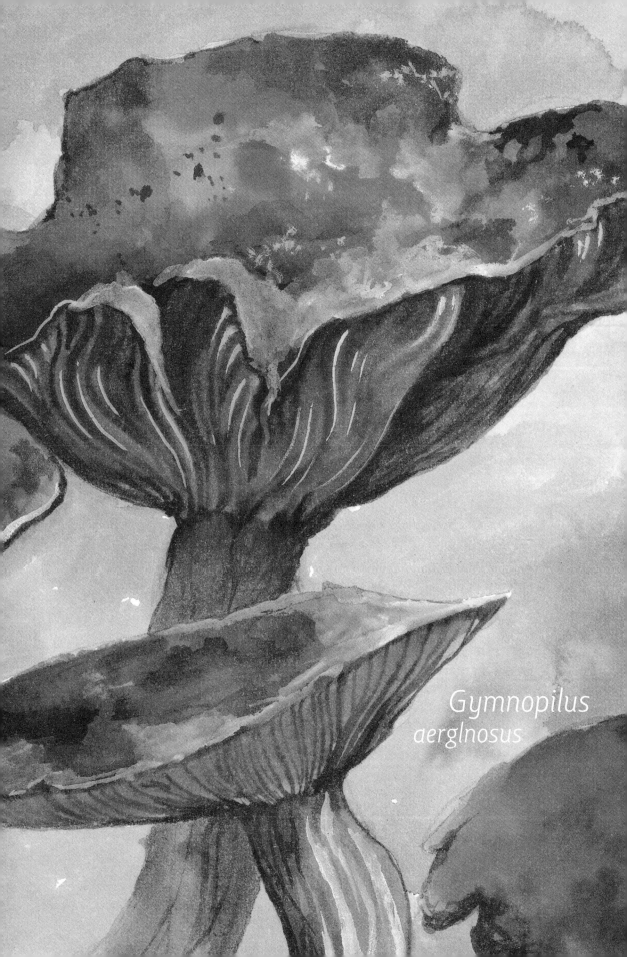

Gymnopilus
aerglnosus

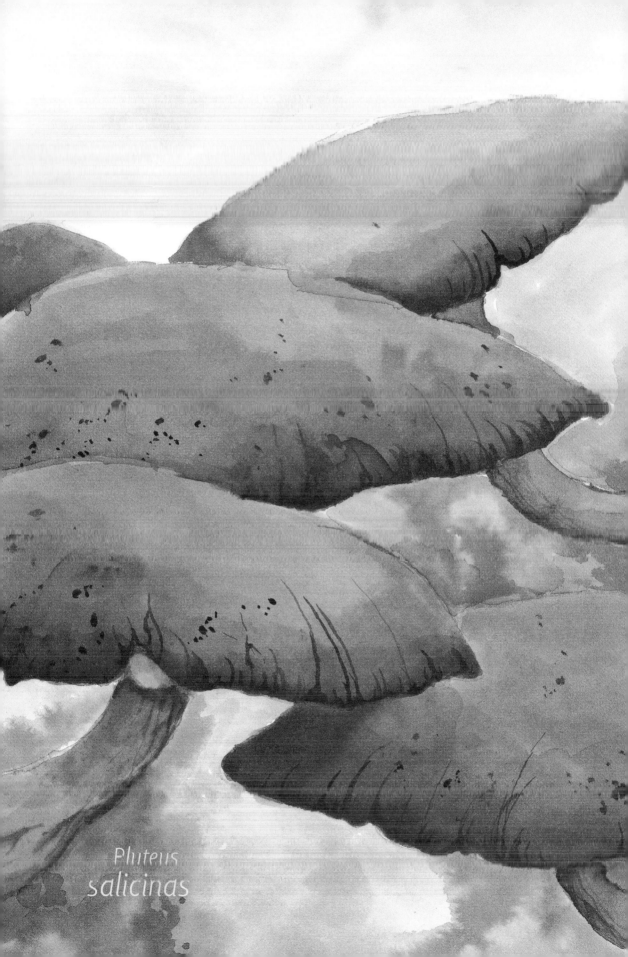

Pluteus
salicinas

Pluteus is a genus of mostly small,

dark-capped gilled mushrooms that occur singly and in clusters on

wood and in wood mulch. They are mostly nondescript, innocuous

mushrooms that decompose logs and stumps. The mushrooms have

white gills that turn a pinkish color on maturity and produce a pinkish

to pinkish-brown spore print. The stem is mostly slender and, if twisted

carefully, can be pulled out from the mushroom without breaking any of

the gills. The common Pluteus, the Fawn Mushroom (*Pluteus cervinus*), is

also one of the largest in the genus, with caps up to four inches across.

It occurs throughout much of North America, Europe, and Asia, and is

an edible if not noteworthy mushroom. One species is known to stain

blue on bruising and this species, *Pluteus salicinus*, grows singly on logs

across northern North America during the summer and fall. It wouldn't

be noticed except that the grayish cap and whitish stem do stain blue

on bruising, and it has been shown to contain psilocybin, making it a

curious little psychoactive mushroom.

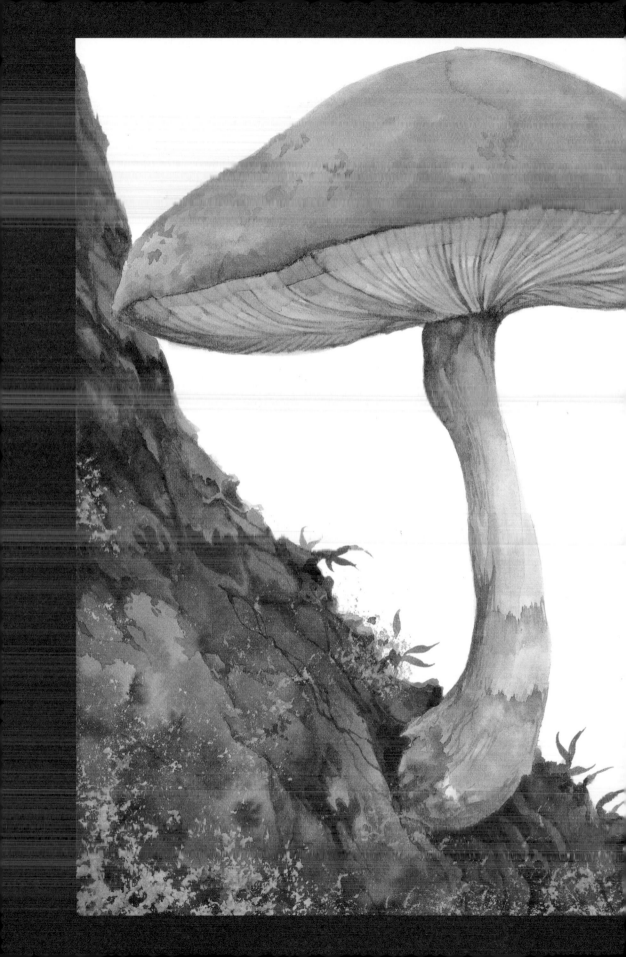

Pluteus
salicinas

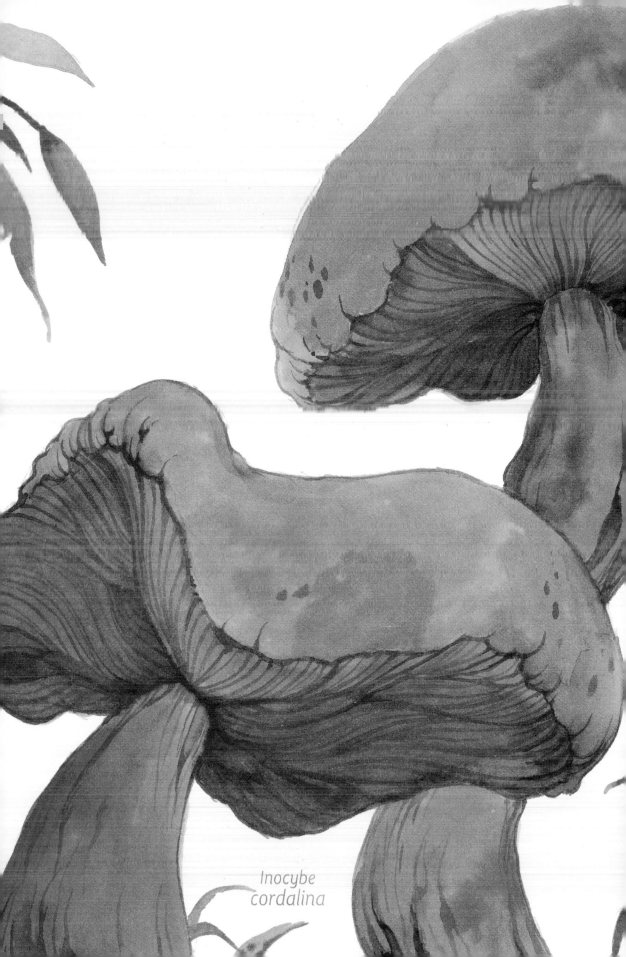

Inocybe
cordalina

Inocybe is a genus of LBMs, Little

Brown Mushrooms. They all occur on ground associated with conifers or broad-leaved trees like oaks, beech, birch, poplars, and willows. They are mostly small-capped, slender-stemmed, little brown-colored mushrooms with gray-brown gills that produce a brown to rusty brown spore print. The caps are recognizable because they either have dense fibrils radiating from the center of the cap to the cap margin, or there are wart-like scales arranged over the cap surface. Almost all of them are believed to be poisonous—they contain a toxin called muscarine that produces symptoms that include profuse sweating and difficulty seeing. The poisoning is rarely fatal but deaths have been reported in Europe. Curiously, this genus also includes a few species that have been shown to contain psilocybin, the same compound found in the magic mushroom genus Psilocybe. One of these species, the *Inocybe aeruginascens*, stains a greenish color on bruising. It can be found in sandy soils under poplars and willows. The reported "poisonings" from *Inocybe aeruginascens* were from mistaking the mushroom for the edible grassland mushroom known as the Fairy Ring mushroom, *Marasmius oreades*. The resulting hallucinations alerted people that there was more to this mushroom than met the eye.

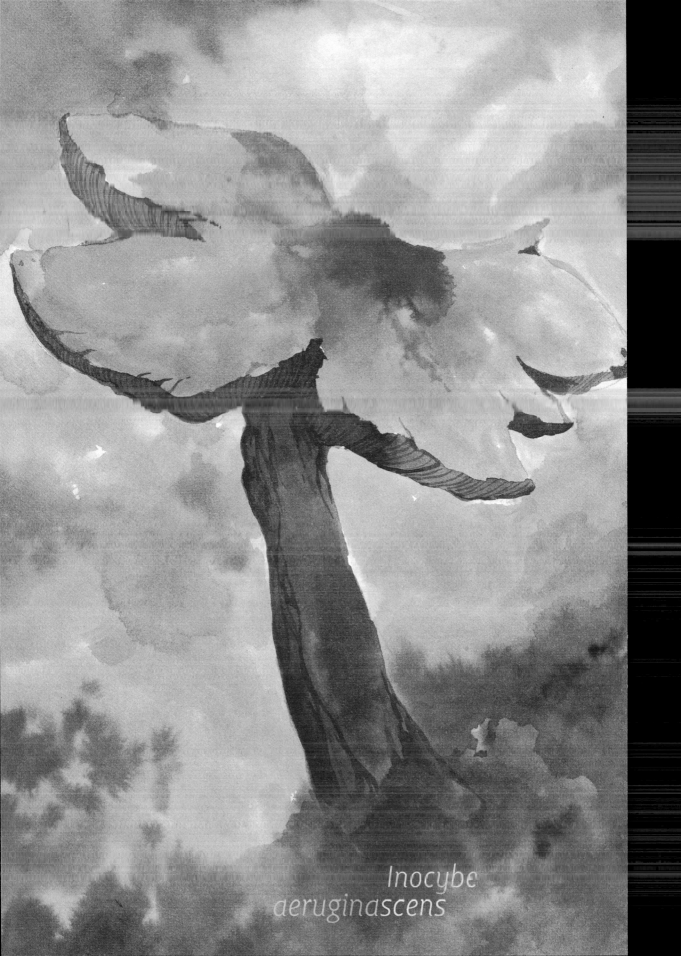

Inocybe
aeruginascens

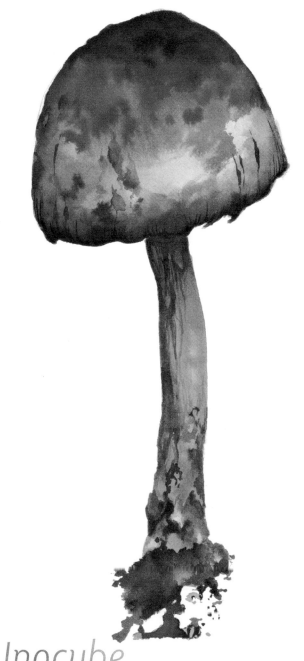

Inocybe
calamistrata

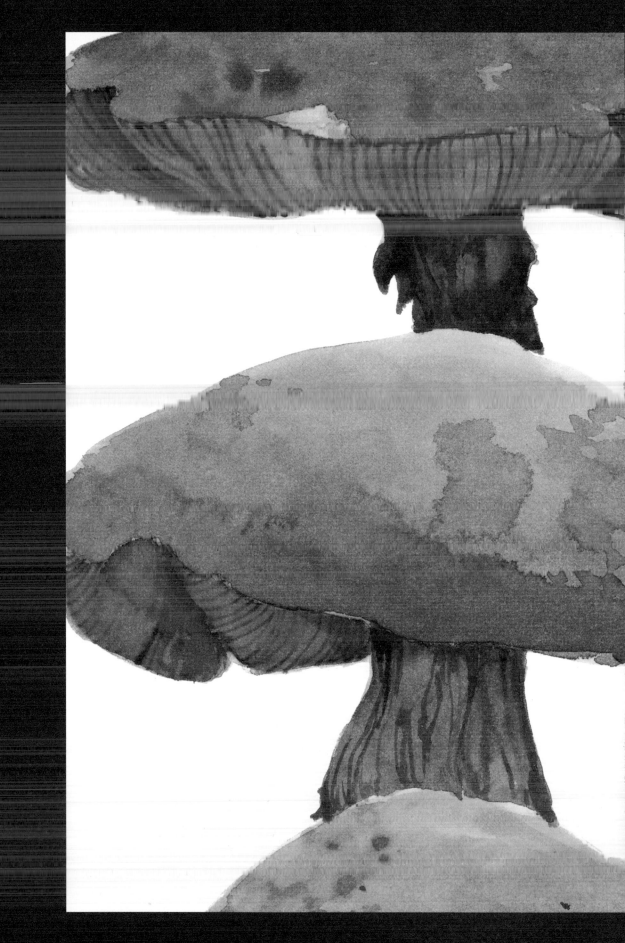

Inocybe
haemacta

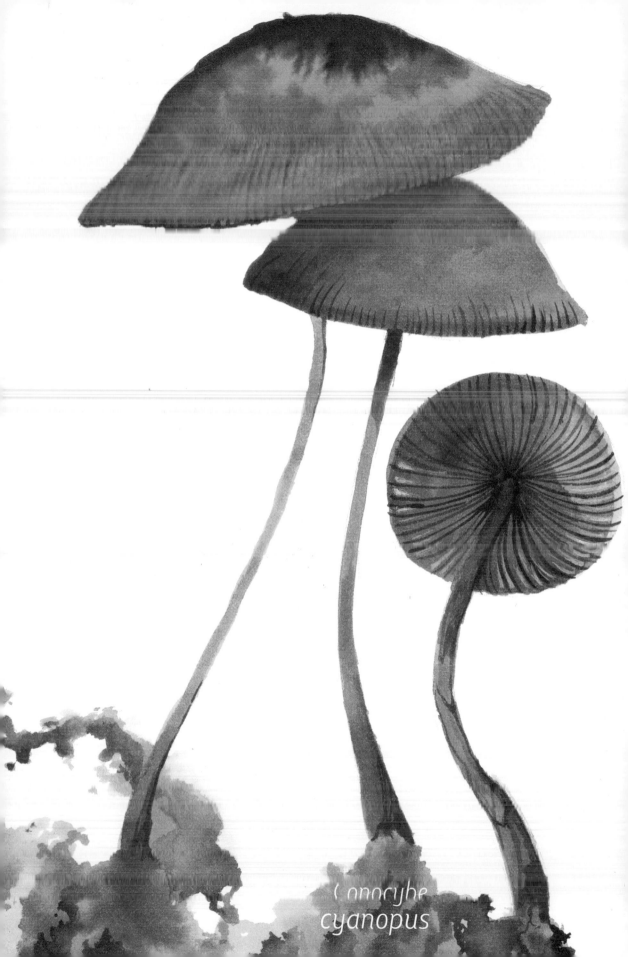

Conocybe
cyanopus

Conocybe

Conocybe is a genus of lawn and

woodland mushrooms that are easily overlooked. Those that grow in lawns often come up overnight and have fallen over before noon. These are often called dunce caps because the shape of the cap is similar to the classic dunce's hat. The mushrooms are small, with caps rarely one inch across, and stems that are slender, sometimes long (three inches or more), and generally very fragile. Most are some shade of brown with gills that are sometimes a bright cinnamon brown. The spore print is brown to cinnamon brown.

One of these Conocybes is known to be deadly. It contains the same toxin as the Destroying Angel Amanita. This *Conocybe filaris* can be recognized because, unlike other species in this genus, it has an annulus or ring on the upper stem. There are also at least two species that are psychoactive. *Conocybe cyanopus* and *Conocybe smithii* have stems that stain blue near the base. While thin and fragile, if found in numbers they have been shown to produce hallucinations when ingested. Care must be taken not to mistake these Conocybes with the deadly species of Galerina, little brown mushrooms that grow on wood or in grass and have a ring on their stem. Deadly Galerinas contain the same lethal toxins as the Destroying Angel Amanitas!

Afterword

I've always drawn mushrooms. They grow from the tip of my pen without much effort, springing to life exactly as they do in the wild. My subconscious mind tends to produce these mushroom depictions by default, as though they are the most natural of all subjects.

This book is an attempt to document a specific and mysterious kingdom of mushrooms—those that interact with human chemistry in a magical way. The images presented herein are my own interpretation of the character of each of these mushrooms. When I observed these fungi closely, they appeared fantastically strange and distantly familiar at once. They looked to me like nerve endings winding their way from the center of the Earth charged with information and memories from a cosmic prehistory of our planet and the horizons of our consciousness. I always wondered how and why these mushrooms and their unique alkaloids cooperated with my mind in such a meaningful way.

Nature is a complex phenomenon that has experimented and evolved models of life since the dawn of the habitable Earth. Since all life on Earth evolved from the same elements, our similarities with even the oddest life forms are greater than our differences. With this in mind, the concept of communication between species on some level seems quite reasonable. Plants and insects communicate; animals and humans communicate; thus, could not a similar communication occur between human beings and fungi?

The plant and fungi kingdoms are a wealth of chemistry both medicinal and toxic, and it's been said that for every known illness there is a cure to be found in nature. I imagine that the mushroom may be an antidote to the sickness of the rampant human ego, a byproduct of the mind under which we are all suffering today. Mushrooms have the potential to provide an inspirational reconnection to nature and divinity necessary for our species.

Traditions involving mushroom experiences maintained since ancient times offer some clues to unlocking these mysteries. Ceremonial mushroom rituals of Mexico and Central America are well documented, but the mushroom experience has been the catalyst for many other religious traditions and spiritual philosophies as well.

I think we owe it to ourselves as the "most advanced" species on the planet to make an effort to comprehend how it is possible that our minds and imaginations can be so stimulated by a humble fungus growing from the decaying remains of life. Mushrooms could be the alchemical ideal, the phoenix rising from the ashes, and the resurrection myth made flesh. Just as the divine shows its face from time to time through the layers of the world, the mycelium network flows underground, occasionally revealing signs that hope emerges from the ruins.

Arik Roper

Disclaimer

The material contained in this book is presented only for informational and artistic purposes. The publisher, artist, and authors do not condone or advocate in any way the use of prohibited substances or illegal activity of any kind. If you eat mushrooms which you may find, you are doing so at your own risk. The artist and authors have made every effort to provide well-researched, sufficient, and up-to-date information, however we also urge caution in the use of this information. The publisher, authors, and artist accept no responsibility or liability for any errors, omissions, or misrepresentations, expressed or implied, contained herein, or for any errors the reader might make in identifying mushrooms, for any harmful reactions to eating poisonous mushrooms, or for any specific reactions to eating any mushrooms. Readers should seek health and safety advice from physicians and safety professionals.

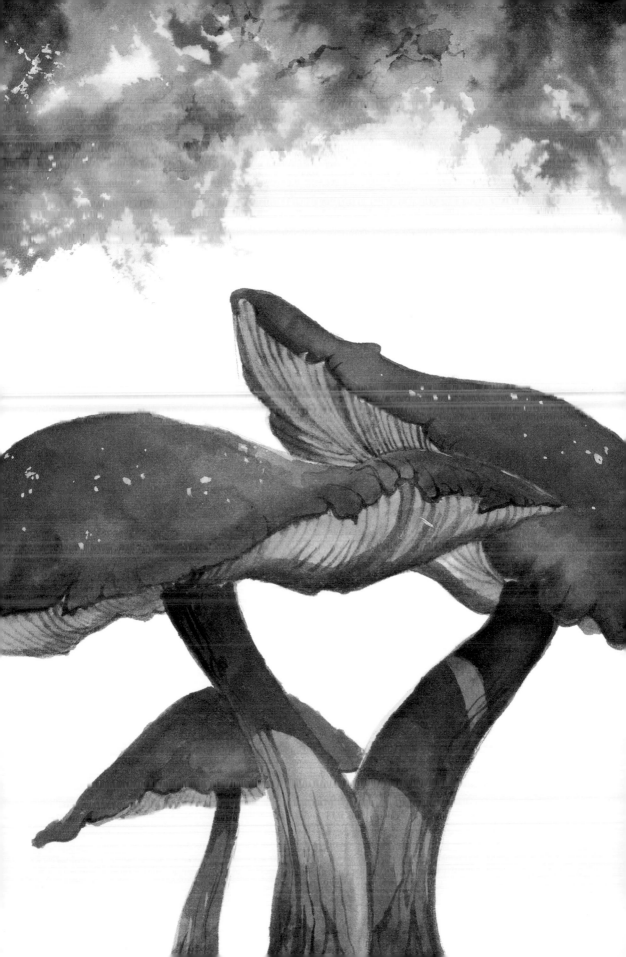

Bibliography

Allegro, John Marco. *The Sacred Mushroom and the Cross: A Study of the Nature and Origins of Christianity Within the Fertility Cults of the Ancient Near East.* London: Hodder & Stoughton Ltd., 1970.

Lechter, Andy. *Shroom: A Cultural History of the Magic Mushroom.* New York: Harper Perennial, 2008.

McKenna, Terrence. *The Invisible Landscape: Mind, Hallucinogens, and the I Ching.* New York: HarperOne, 1994.

_____. *True Hallucinations: Being an Account of the Author's Extraordinary Adventures in the Devil's Paradise.* New York: HarperOne, 1994.

Norland, Richard. *What's in a Mushroom.* London: Pear Tree Publications, 1976.

Ratsch, Christian. *The Encyclopedia of Psychoactive Plants.* London: Park Street Press, 2005.

Stamets, Paul. *Psilocybe Mushrooms and their Allies.* Seattle: Homestead Book Company, 1982.

_____. *Psilocybin Mushrooms of the World.* Berkeley: Ten Speed Press, 1996.

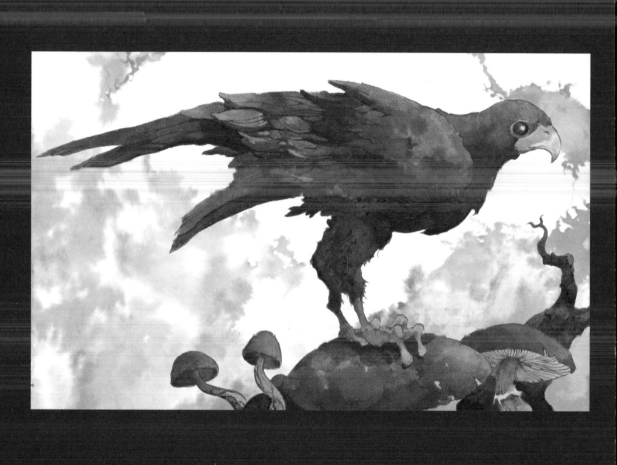

Acknowledgments

Thank you to the following people for their support, ideas, and inspiration for this book: Eva Prinz, Sylvia Barnes, Eric Himmel, Kara Strubel, Laura Klynstra, and Jacquie Poirier at Harry N. Abrams, Inc.; Jay Babcock at *Arthur* magazine; Erik Davis, Daniel Pinchbeck, Gary Lincoff, Lux at Erowid, Gigi, Trinie Dalton and Matt Greene; Dan Donahue, Pepper and Othello, Raasa Leela, my parents, my family, and my friends; as well as Terrence McKenna, Paul Stamets, and all the other thinkers, artists, and writers who have helped open creative windows for me, the spirit, the universe, and the mushroom. I strongly encourage anyone interested in mushrooms and their history to pursue the books listed in the bibliography, many of which were vital to me for information and ideas in the conception of this project.

Arik Roper

Editor: Eva Prinz
Designer: Michelle Ishay
Production Manager: Jacquie Poirier

Cataloging-in-Publication Data has been applied for and may be obtained
from the Library of Congress

ISBN: 978-0-8109-9631-1

HNA ▌▌▌▌▌
harry n. abrams, inc.
a subsidiary of La Martinière Groupe
115 West 18th Street
New York, NY 10011
www.hnabooks.com

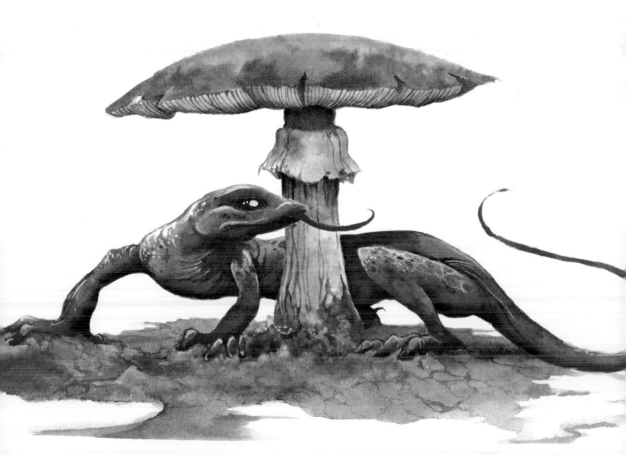